Nearest Earthly Place to Paradise

The Literary Landscape of Shropshire

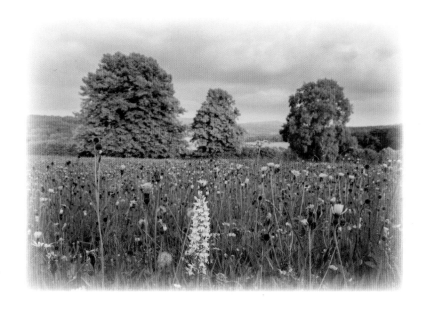

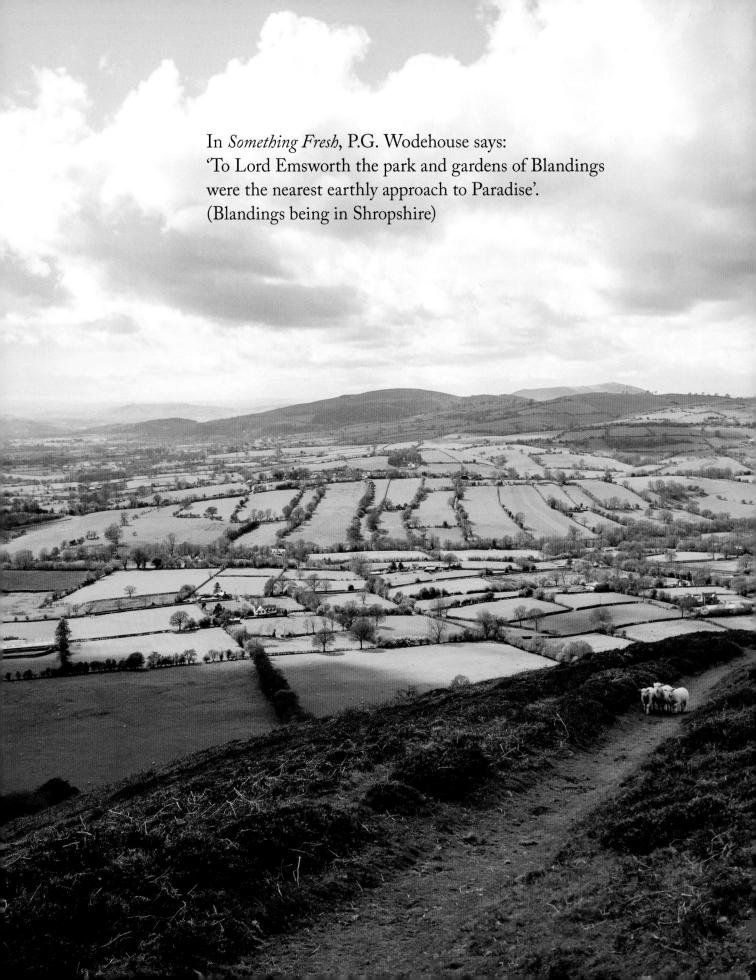

In *Something Fresh*, P.G. Wodehouse says:
'To Lord Emsworth the park and gardens of Blandings
were the nearest earthly approach to Paradise'.
(Blandings being in Shropshire)

NEAREST EARTHLY PLACE TO PARADISE

The Literary Landscape of Shropshire

Editor: Margaret Wilson
Photographer: Geoff Taylor

MERLIN UNWIN BOOKS

First published in Great Britain by Merlin Unwin Books, 2013

Text copyrights belong to the individual copyright holders
Photographs © Geoff Taylor, 2013
Editor: Margaret Wilson

Merlin Unwin Books Ltd
Palmers House
7 Corve Street
Ludlow, Shropshire SY8 1DB U.K.

www.merlinunwin.co.uk

A CIP catalogue record for this book is available from the British Library.
ISBN 978-1-906122-52-2
Designed and set in Caslon 13pt by Merlin Unwin
Printed and bound by Latitude Press

Ellis Peters, author of the Cadfael mysteries and much else, was born and bred in Shropshire. She said she had 'never yet found any sound reason for leaving it, except perhaps for the pleasure of coming back to it again'.

CONTENTS

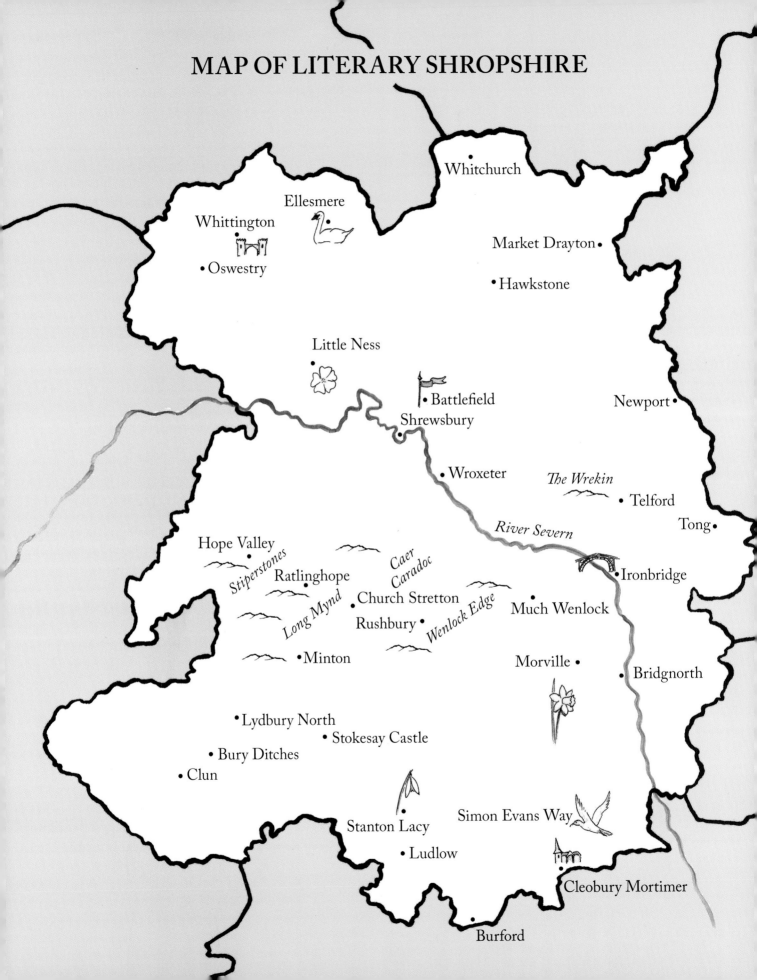

MAP OF LITERARY SHROPSHIRE

Whitchurch

Ellesmere

Whittington

Market Drayton

Oswestry

Hawkstone

Little Ness

Battlefield

Newport

Shrewsbury

Wroxeter

The Wrekin

Telford

Tong

River Severn

Hope Valley

Stiperstones

Caer Caradoc

Ratlinghope

Ironbridge

Long Mynd

Church Stretton

Much Wenlock

Rushbury

Wenlock Edge

Minton

Morville

Bridgnorth

Lydbury North

Stokesay Castle

Bury Ditches

Clun

Simon Evans Way

Stanton Lacy

Ludlow

Cleobury Mortimer

Burford

EDITOR'S PREFACE

In the city there are clues which mark the changing seasons: Christmas lights suggest it's sometime between August and January, while flip-flops in the shops indicate the other half of the year. Yet living in the country, there are subtle changes on a weekly basis: fresh molehills in the snow signalling the thaw; the bronze haze on the alders or mauve on the birches before the leaves even think of opening; the first swallow to welcome. Of course, someone else will have already seen the first swallow last Thursday or heard the cuckoo the week before you. In such a rural county as Shropshire, most people lead busy lives with little time to record their thoughts on the surrounding beauty but this doesn't mean that it goes unappreciated, as author and farmer Roger Evans demonstrates.

Shropshire is the largest of England's inland counties and is sparsely populated, remarkably unspoilt and one of the most attractive, with a great variety of scenery. Although Ludlow, with its food and arts festivals, attracts much attention, the county is a rather well-kept secret. This is a border county that was fiercely fought over for many generations. Centuries of turbulence have left their echo in Iron Age hill forts, castles and fortified manor houses and also a rich store of folklore. There is a sense of place, a *genius loci*, that fosters a feeling of belonging which is reassuring in a busy world.

Many English writers are closely associated with a particular region of the country: the Brontës writing about Yorkshire, Thomas Hardy about Wessex and Daphne du Maurier about Cornwall. Their love and deep understanding of the character of an area enables them to portray it sensitively and vividly so they become perpetually linked. In the foreword to *Precious Bane*, Mary Webb explained how fortunate she felt in being born and brought up in the magical atmosphere of Shropshire. Her bond with the Shropshire countryside and love of nature is shown in her detailed observation and the extent to which the characters in her novels are influenced and affected by their surroundings. Wilfred Owen, perhaps understandably, is also thinking of the gentle landscape of his Shropshire home when writing of the horrors of the front line in his poem *Spring Offensive*. A.E. Housman wrote many of his lyrical poems in *A Shropshire Lad* before even visiting the county but had always viewed Shropshire, lying beyond the western horizon of his Worcestershire home, as a romantic unknown.

The natural beauty of the patchwork fields, the wooded hills or jagged rocky ridges have inspired many other visiting writers who have found time to stop and gaze, absorb something of its quintessential character then describe it perceptively. I hope that my choice of descriptions of this landscape combined with Geoff Taylor's lovely photographs will give pleasure in recognition of the familiar and encouragement to discover new aspects of this beautiful county.

Margaret Wilson, Leebotwood, July 2013

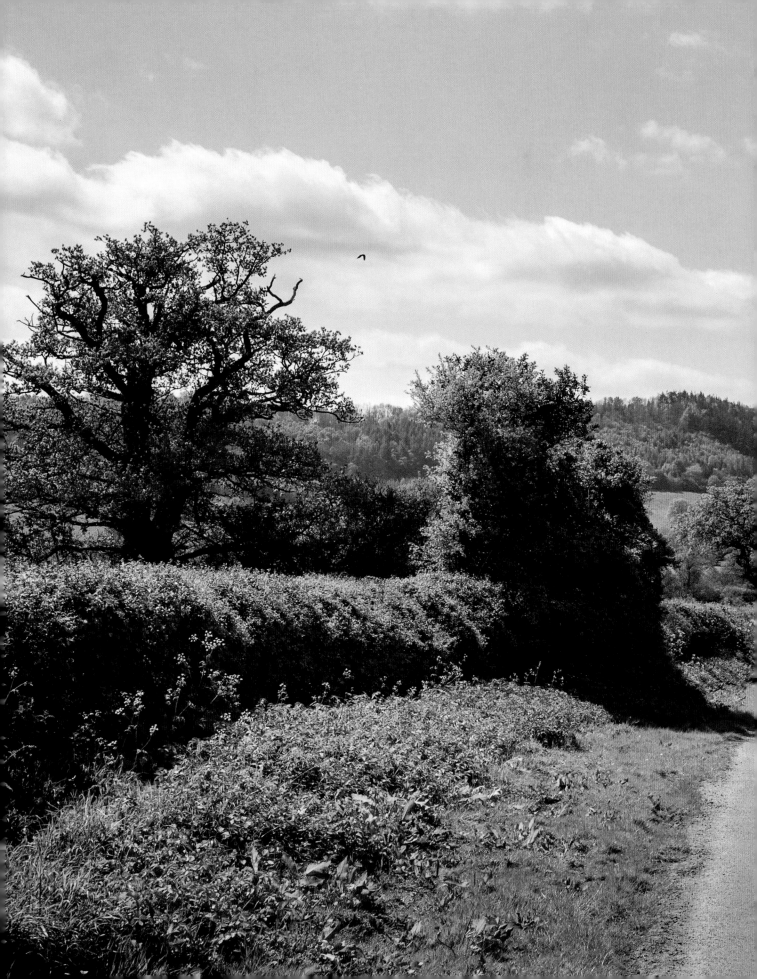

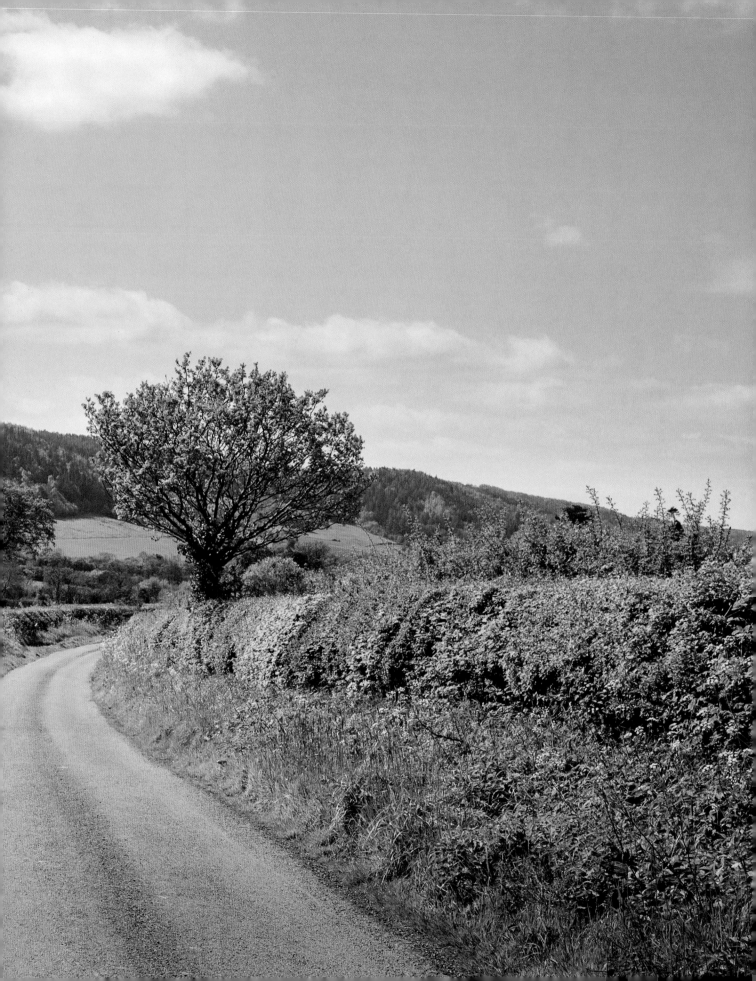

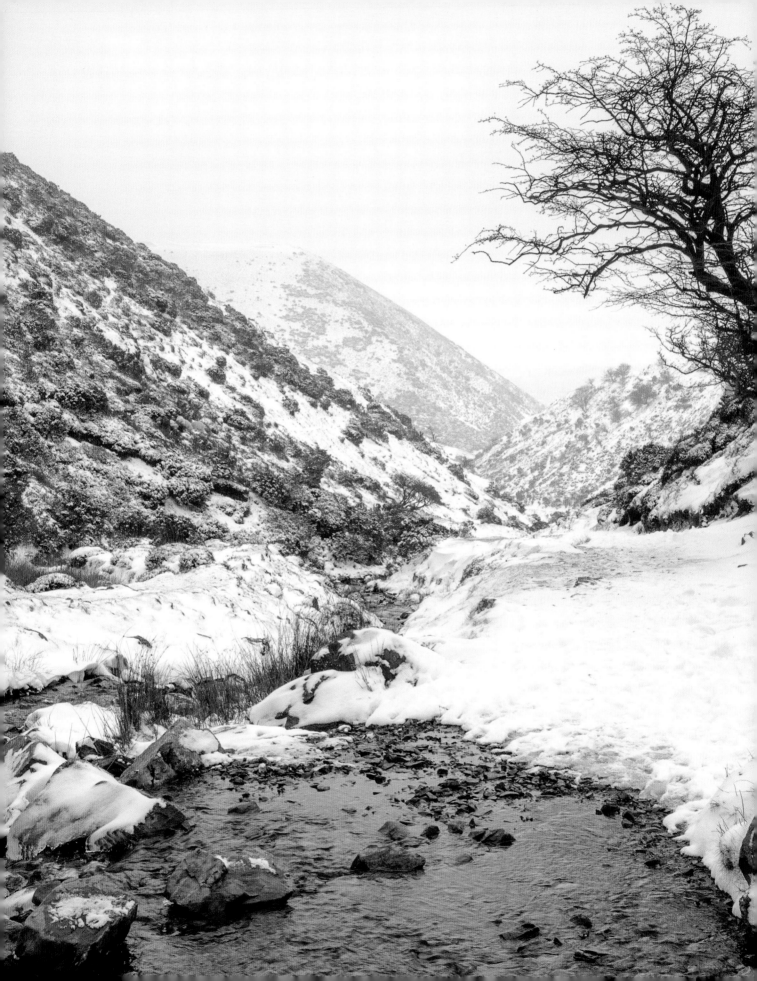

REVEREND E. DONALD CARR

A Night in the Snow

– or A Struggle for Life

Suddenly my feet flew from under me, and I found myself shooting at a fearful pace down the side of one of the steep ravines which I had imagined lay far away to my right. I thought to check myself by putting my stick behind me and bearing heavily upon it in the manner usual under such circumstances in Alpine travelling. Before, however, I could do so I came in contact with something which jerked it out of my hand and turned me round, so that I continued my tremendous glissade head downwards, lying on my back. The pace I was going in this headlong descent must have been very great, yet it seemed to me to occupy a marvellous space of time, long enough for the events of my whole previous life to pass in review before me, as I had often before heard that they did in moments of extreme peril. I never lost my consciousness, but had time to think much of those I should leave behind me, expecting every moment as I did to be dashed over the rocks at the bottom of the ravine; knew in fact that such must be my fate, unless I could stop myself by some means. Owing to the softness of the snow, I contrived to accomplish this by kicking my foot as deep into the snow as I could, and at the same time bending my knee with a smart muscular effort, so as to make a hook of my leg; this brought me to a stand still, but my position was anything but agreeable even then, hanging head downwards on a very steep part, and never knowing any moment but what I might start again.

From Rev. Carr's account of his night spent lost on the Long Mynd in the terribly bad winter of January 1865. He was attempting to return to his parish in Woolstaston after struggling through deep snow to conduct a service in Ratlinghope.

A Night in the Snow, published by Onny Press, Craven Arms, 1970

Photo: Carding Mill Valley and Bodbury Hill

D.H. LAWRENCE

St. Mawr

They rode up again, past the fox gloves under the trees. Ahead, the brilliant St. Mawr, and the sorrel and grey horses were swimming like butterflies through the sea of bracken, glittering from sun to shade, shade to sun. Then, once more they were on a crest, and through the thinning trees could see the slopes of the moors beyond the next dip.

Soon they were in the open, rolling hills, golden in the morning and empty save for a couple of distant bilberry-pickers, whitish figures pick—pick—picking with curious, rather disgusting assiduity. The horses were on an old trail which climbed through the pinky tips of heather and ling, across patches of green bilberry. Here and there were tufts of hare-bells blue as bubbles.

They were out, high on the hills. And there to west lay Wales, folded in crumpled folds, goldish in the morning light, with its moor-like slopes and patches of corn uncannily distinct. Between was a hollow, wide valley of summer haze, showing white farms among trees, and grey slate roofs.

After visiting friends in Pontesbury, Lawrence wrote St Mawr in 1924 and set some scenes around the Stiperstones. The bay stallion, St Mawr, represents the vitality Lawrence felt was lacking in modern man in the industrialised world.

St Mawr, published by Granada Publishing Limited, London, 1983

Photo: Foxgloves and bracken on Little Caradoc

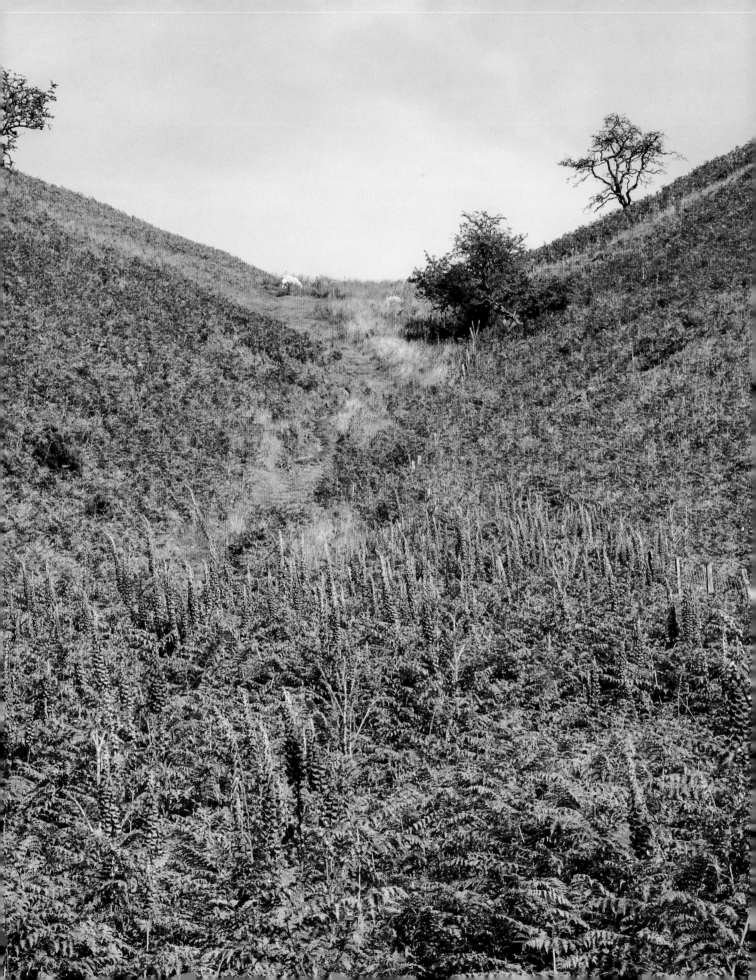

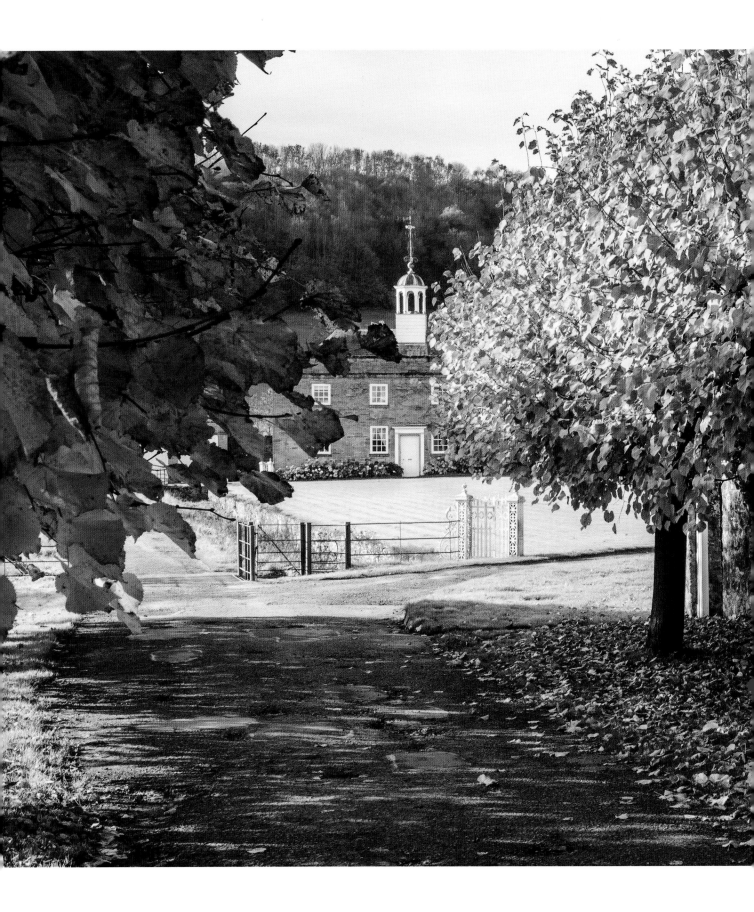

KATHERINE SWIFT

The Morville Hours

The wound-up watch-spring of summer is winding down. The days fill with rounded golden light, like a rich old Sauternes, full and sweet. Sugars caramelise in the leaves – tones of butterscotch, cinder toffee, treacle tart; quince paste, marmalade, toffee apple; Beaujolais, cassis, Lynch-Bages. The hedgerow shines with great plates and bunches of glossy berries like so many jars of jelly and jam ranged on a larder shelf – scarlet hip and crimson haw; red bullace and yellow crab; purple elderberry and blue-black sloe. Trees blaze, as if a reverse photosynthesis were taking place, green chlorophyll turning back into pure energy.

Katherine Swift describes creating her garden at the Dower House in Morville, and links it with previous occupants of the house, their lives and the garden they tended.

Bloomsbury Publishing plc, London, 2008

Photo: Drive leading to the Gate House of Morville Hall and the church of St Gregory the Great

HENRY KINGSLEY

Stretton

The crystal purity of a perfect evening at the end of April was settling down over the beautiful valley which lies between Shrewsbury and Ludlow; on the one hand, the Longmynd rolled its great sheets of grouse-moor and scarps of rock up, fold beyond fold; while, on the other, the sharp peak of Caradoc took the evening, and smiled upon his distant brother, the towering Plinlimmon; while Plinlimmon, in the West, with silver infant Severn streaming down his bosom, watched the sinking sun after Caradoc and Longmynd had lost it; and when it sank, blazed out from his summit a signal to his brother watchers, and, wrapping himself in purple robes, slept in majestic peace.

Down below in the valley, among the meadows, the lanes, and the fords, it was nearly as peaceful and quiet as it was aloft on the mountain-tops; and under the darkening shadows of the rapidly leafing elms, you could hear, it was so still, the cows grazing and the trout rising in the river. Day was yet alive in some region aloft in the air, loftier than the summits of Plinlimmon or Caradoc, for the democratic multitude of the stars had not been able as yet to show themselves through the train of glorious memories which the abdicated king had left behind him. The curfew came booming up the valley sleepily, and ceased. It was a land lapped in order and tradition; good landlords, good tenants, well-used labourers, if ever there were such in late years in England. Surely a land of peace!

Henry Kingsley, brother of Charles, tells the story of families living in Church Stretton and Church Pulverbatch in 1869.

Stretton, published by Ward, Lock & Bowden Ltd, London, 1895

Photo: Caer Caradoc from Gogbatch

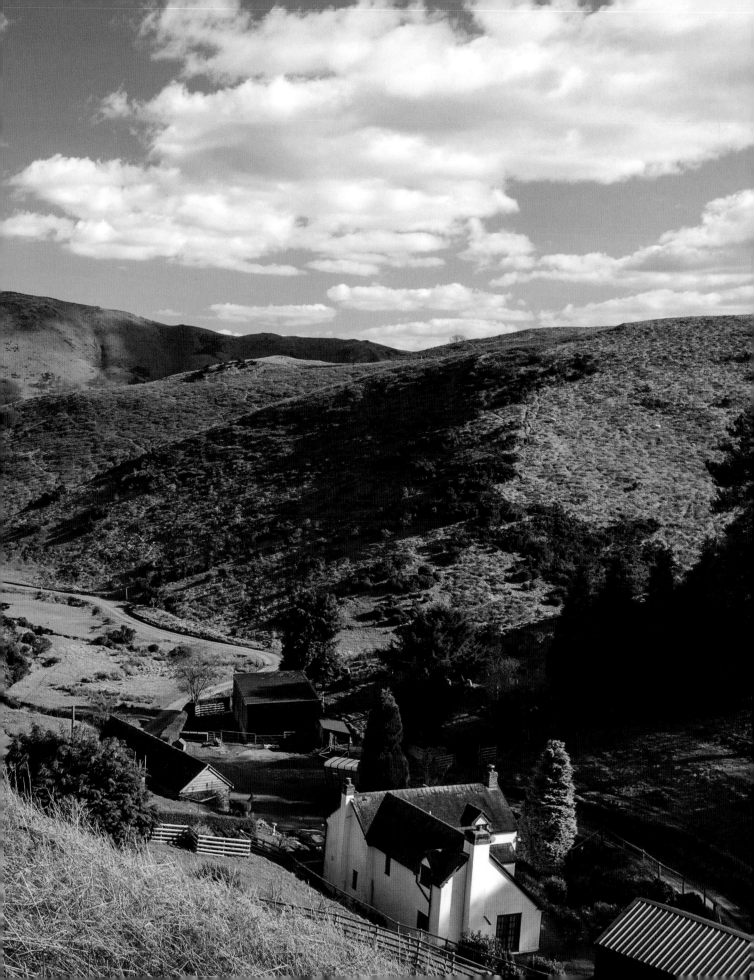

WILFRED OWEN

Spring Offensive

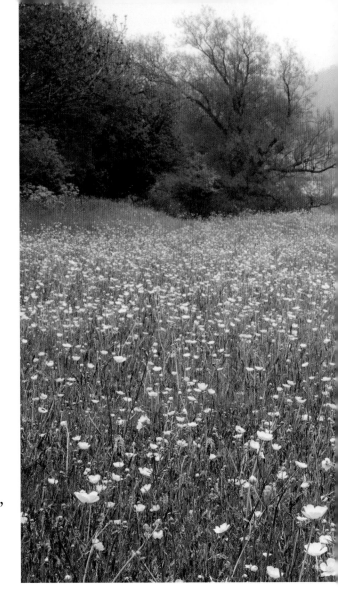

Halted against the shade of a last hill
They fed, and eased of pack-loads, were at ease;
And leaning on the nearest chest or knees
Carelessly slept.

 But many there stood still
To face the stark blank sky beyond the ridge,
Knowing their feet had come to the end of the world.
Marvelling they stood, and watched the long grass swirled
By the May breeze, murmurous with wasp and midge;
And though the summer oozed into their veins
Like an injected drug for their bodies' pains,
Sharp on their souls hung the imminent ridge of grass,
Fearfully flashed the sky's mysterious glass.

Hour after hour they ponder the warm field
And the far valley behind, where buttercups
Had blessed with gold their slow boots coming up;
When even the little brambles would not yield
But clutched and clung to them like sorrowing arms.
They breathe like trees unstirred.

Till like a cold gust thrills the little word
At which each body and its soul begird
And tighten them for battle. No alarms
Of bugles, no high flags, no clamorous haste –
Only a lift and flare of eyes that faced
The sun, like a friend with whom their love is done.
O larger shone that smile against the sun, -
Mightier than his whose bounty these have spurned.

So, soon they topped the hill, and raced together
Over an open stretch of herb and heather
Exposed. And instantly the whole sky burned
With fury against them; earth set sudden cups
In thousands for their blood; and the green slope
Chasmed and deepened sheer to infinite space.

Of them who running on that last high place
Breasted the surf of bullets, or went up
On the hot blast and fury of hell's upsurge,
Or plunged and fell away past this world's verge
Some say God caught them even before they fell

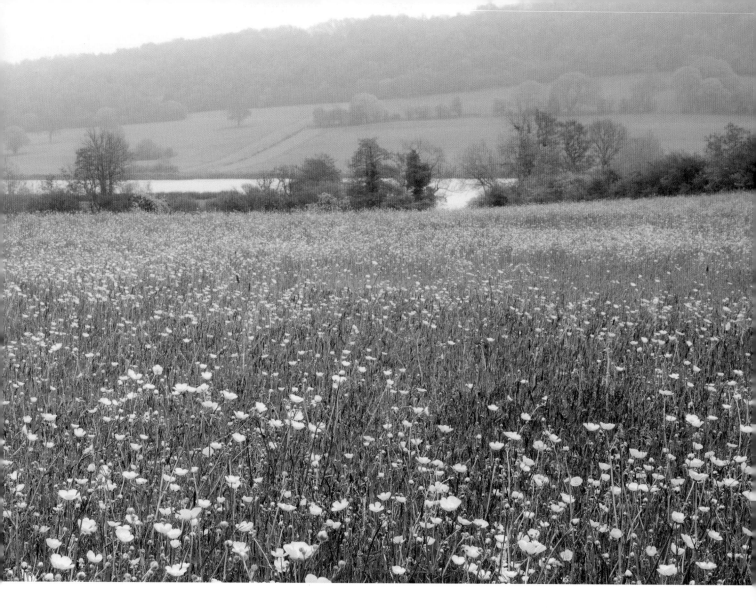

But what say such as from existence' brink
Ventured but drave too swift to sink,
The few who rushed in the body to enter hell,
And there out-fiending all its fiends and flames
With superhuman inhumanities,
Long-famous glories, immemorial shames –
And crawling slowly back, have by degrees
Regained cool peaceful air in wonder –
Why speak not they of comrades that went under?

Photo: A field of buttercups at Rushbury, below
Wenlock Edge

*Spring Offensive was written in 1918 and is
possibly the last poem Owen worked on. He
was in the spring offensive of 1917 and suffered
shell-shock. His images of trench warfare here
strongly suggest he is thinking of a gentler
Shropshire landscape and this is reinforced by the
fact that Owen had used the phrase 'blessed with
gold' in 1907 when returning through the fields
to Shrewsbury with his family after Evensong
in Uffington church.*

The War Poems of Wilfred Owen, Edited and
Introduced by Jon Stallworthy, published by
Chatto & Windus, London 1994

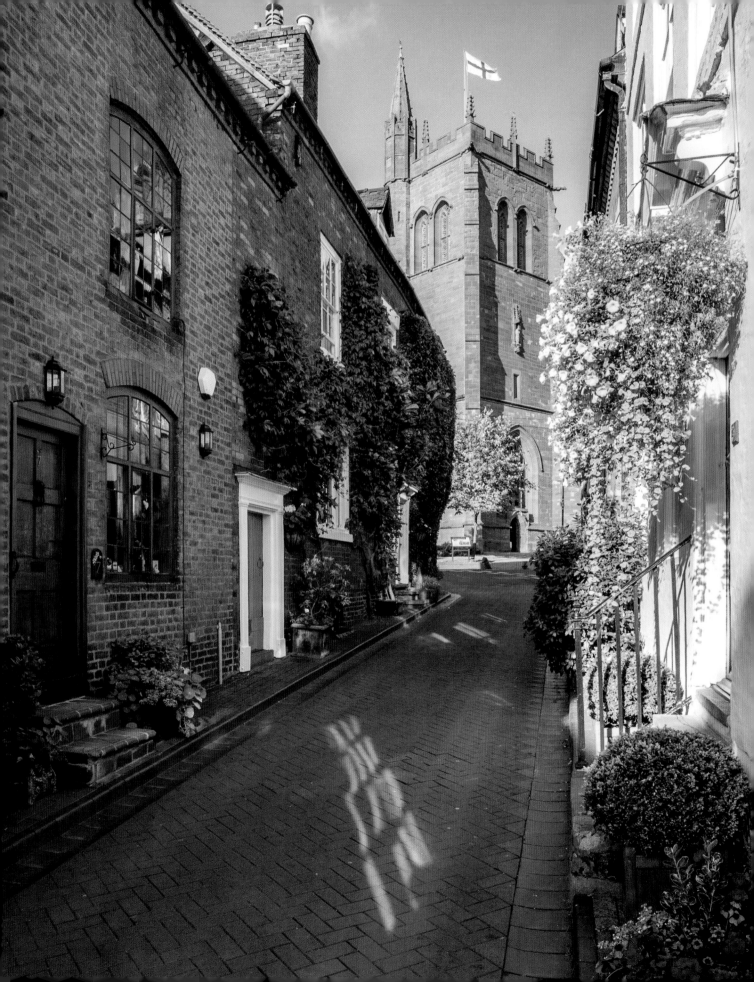

WILLIAM FLETCHER

Talking with Past Hours
The Victorian Diary of William Fletcher of Bridgnorth

27th October 1858

Went to Buildwas – heard that some horse racing amongst the farmers was to take place on the occasion of the return of young Moseley from India. I went, after having got dinner at the Inn, and got into conversation with a youngish farmer named Hoole. Enjoyed the races very much, and afterwards went with Mr Hoole to his house and was well treated. He said there was going to be a tea party down at the Inn, and finish up with a dance. So there we went. I got into the company of 2 or 3 nice girls and enjoyed myself exceedingly. The former part of the evening I had to amuse them all. It was the best lark in the world to see the old cronkes dance hornpipes. The folks couldn't read me at all – couldn't imagine where I'd sprung from. Some said I was a brother to Mr Hoole – which was digested splendiferously. ...Dancing was kept up till 3 o'clock and then I turned in for 2 or 3 hours. Got up 28th at 7. They wouldn't have anything for my bed. Started before breakfast for Wenlock. A very wet morning – rained fast all the way – which place I reached soon after eight. Got a good breakfast, had a nap and felt 'allright' again. ...This writing testifies that I have been on the spree – my hand is not particularly steady today.

William Fletcher was a young Victorian bank clerk writing 1857-60. He describes his work, family life and social activities in Bridgnorth.

Talking with Past Hours, edited by Jane Killick, published by Moonrise Press, Ludlow, 2009

Photo: Church Street and St Leonard's Church, Bridgnorth

ROGER EVANS

Over the Farmer's Gate

The past weeks have seen us out and about on our land on a daily basis, as the seasons and the work progresses. After all these years, I still find the views from our top fields remarkable and remind myself on a daily basis how lucky I am to live and work in such an environment. I took some sandwiches and a drink up to our young tractor driver the other day and took the opportunity to take it all in, while I waited for the tractor to go around the field and come back to the gateway.

When he got off the tractor I told him that we'd got it all wrong. I suggested that it was ridiculous that I was paying him to drive up and down this particular field on such a lovely sunny day, with panoramic views that some people would envy. I went on, quite eloquently, to suggest that it would be much fairer if he paid me for the privilege of doing what he was in such surroundings. He took a sip of tea, thought about it a bit, and said he would rather leave things as they were.

Roger Evans farms at Lydbury North. For many years he has written a column for the Dairy Farmer and also for the Western Daily Press.

Over the Farmer's Gate, published by Merlin Unwin Books, Ludlow, 2010

Photo: Turning the hay near Lydbury North

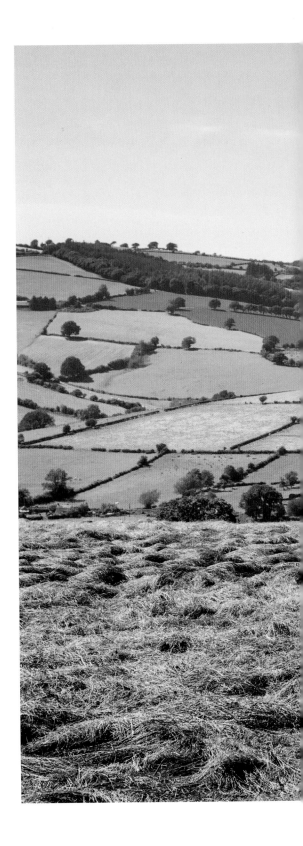

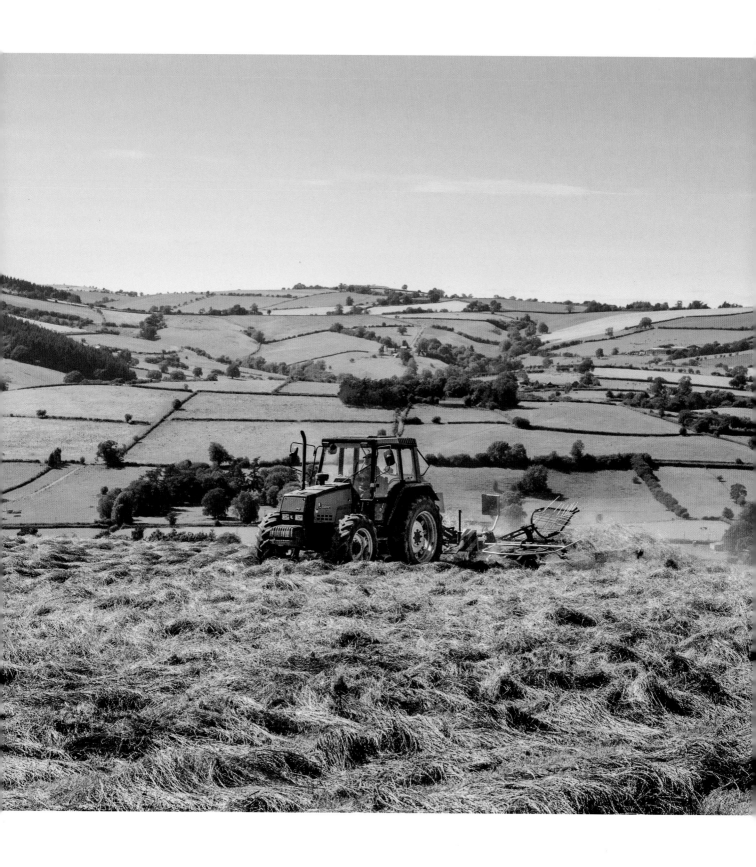

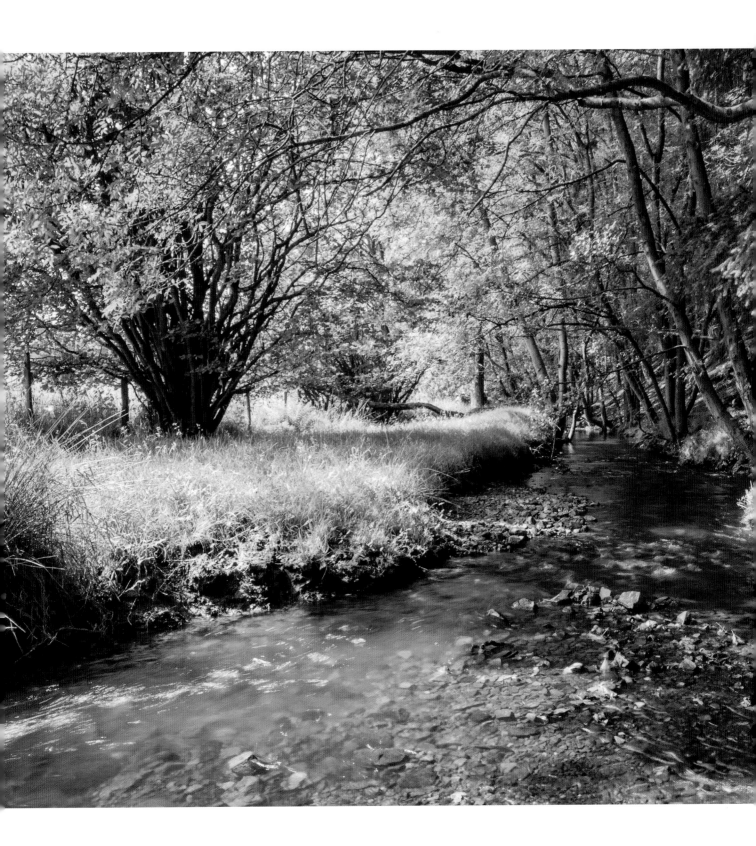

BILL TUER

A Prince Among Poachers

Everyone should have a turn at tickling trout, a real art and loads of fun; both arms in up to your armpits fumbling in the holes in the turf, holes made by rats or water voles, I suppose. Finding a trout you want him coming out over your upturned hand. If he is facing the wrong way tickle gently, he'll soon turn round. It's quite simple when one has got the knack. Close your hand slowly, thumb and forefinger just behind the gills, you've got him. If the fish have little feet get your hand out sharpish, it's probably a water rat protecting its nest.

Bill Tuer writes about his childhood in the Thirties at Ratlinghope where his father was gamekeeper to Sir James Reynolds.

A Prince Among Poachers, published by CC Publishing (Chester), 2004

Photo: Darnford Brook, Ratlinghope

PETER DAVIES

A Corner of Paradise

Whitsuntide was late that year – and more than usually promising. For spring came haltingly to Little Ness. Easter was always cold. Winter returned when the blackthorn bloomed; when we usually killed the pig; and the old pear tree dropped fresh tears like bubbles of milk on the cobblestones outside the house. There might be a lull and soft airs for a week or two, but then the north wind would come out of Ruyton and blast the plum trees in our orchard, scattering snow-like petals along with Mother's washing far and wide. 'Plum winter' we called that.

No wonder we set so much store by Whit. Then, with any luck, we would bathe in the river; then, because it was half-term, we would forget about school, unseens and mock exams; then lilac fountained, laburnum blazed, poppies and paeonies flamed, flattened and fell; the cool wild rose appeared – my favourite flower, God's masterpiece, whose subtle scent and smile He knew I never could resist. Then we might see a purple emperor, a lesser spotted woodpecker, a young fox tenderfooting it across the Cow Lane field, skimming the cowslips as he went; then we might have potatoes fresh from the garden, and early peas with English lamb, and, afterwards, the first pink shoots of rhubarb in a pie.

Peter Davies recalls his youth in rural Shropshire after WWII.

A Corner of Paradise, published by Andre Deutsch Limited, London, 1992

Photo: Pimhill organic farm, Harmer Hill, north Shropshire

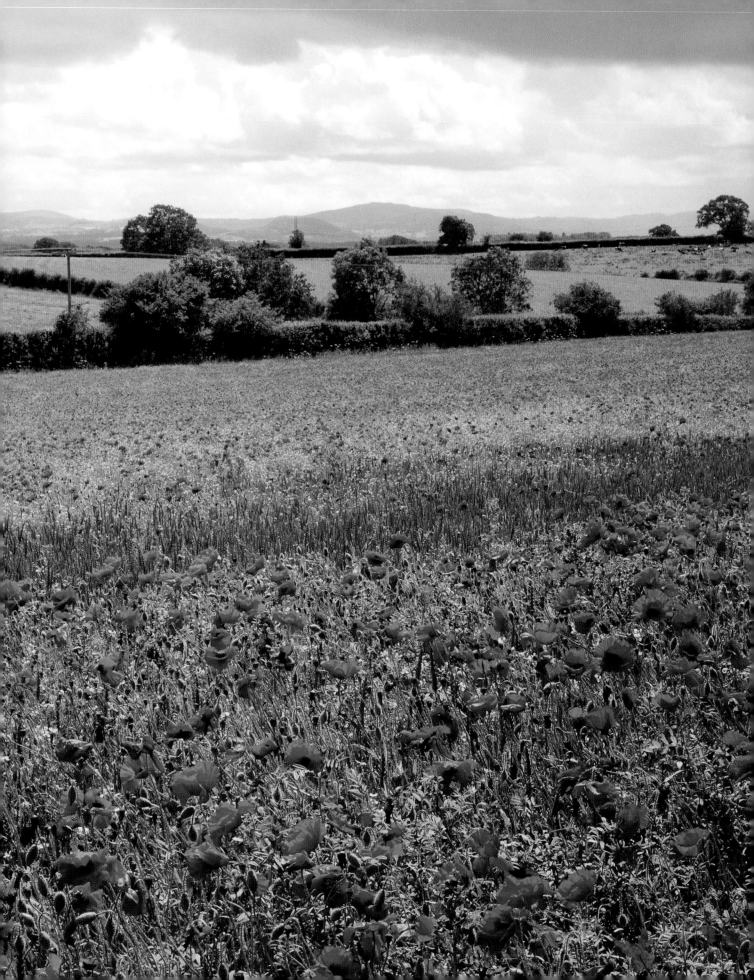

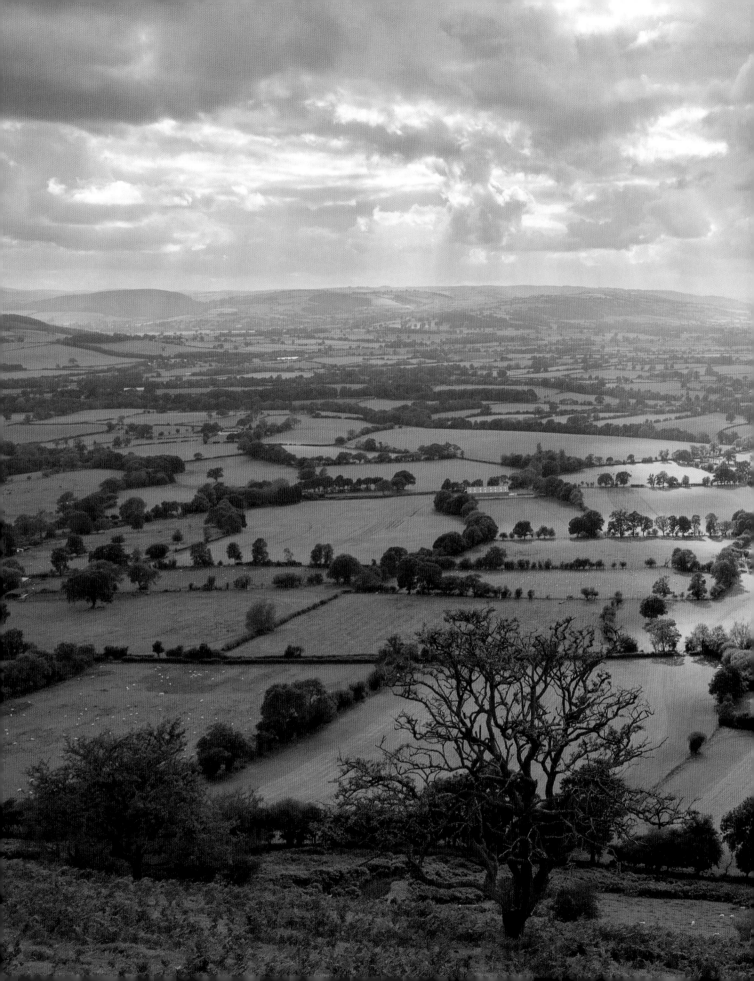

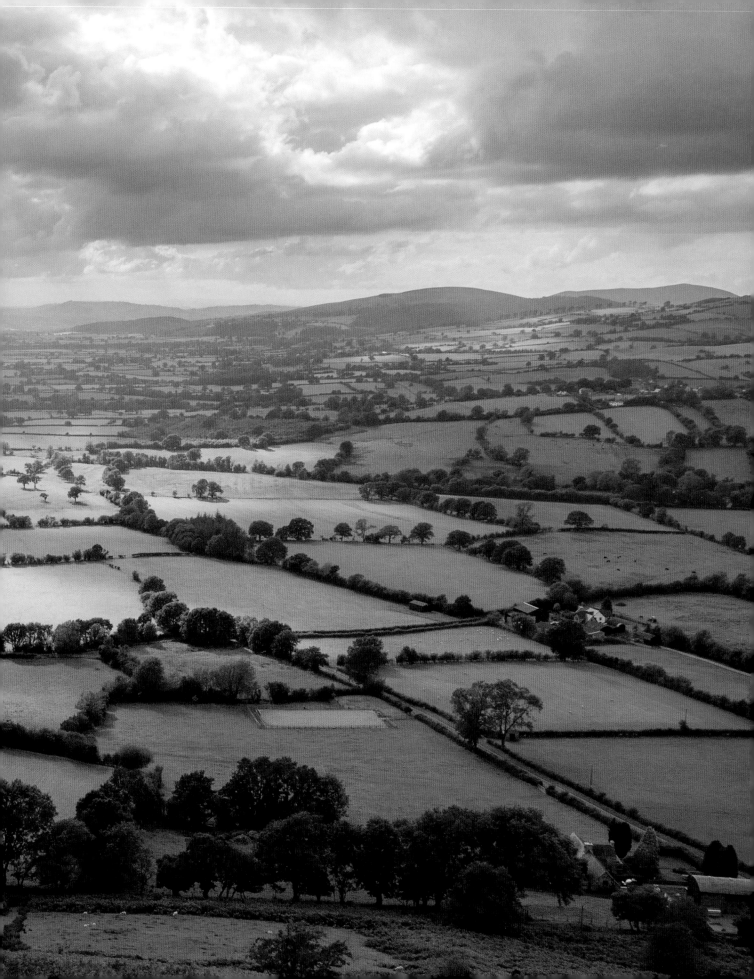

MARY WEBB

Very Early

Very early we will go into the fields tomorrow
And wait beneath the budding elm-tree arches,
Till Earth has comforted her night-long sorrow
And dawn comes golden in the larches.
There's a little hush that falls when the airs lie sleeping;
The sky is like an empty silver bowl,
Till eagerly the blackbird's song goes upward sweeping,
And fills the aery hollows, and the soul.
There's a scent that only comes in the faint, fresh gloaming,
Before the crocus opens for the bees;
So early we will go and meet the young day roaming,
And see the heavens caught among the trees.

*Mary Webb was an English poet and novelist who observed
and described with great perception and intensity the Shropshire
countryside where she lived.*

Selected Poems of Mary Webb, edited by Gladys Mary Coles, published
by Headland Publications, West Kirby, Wirral, 2005

Photo: Wenlock Edge, near Jacob's Ladder

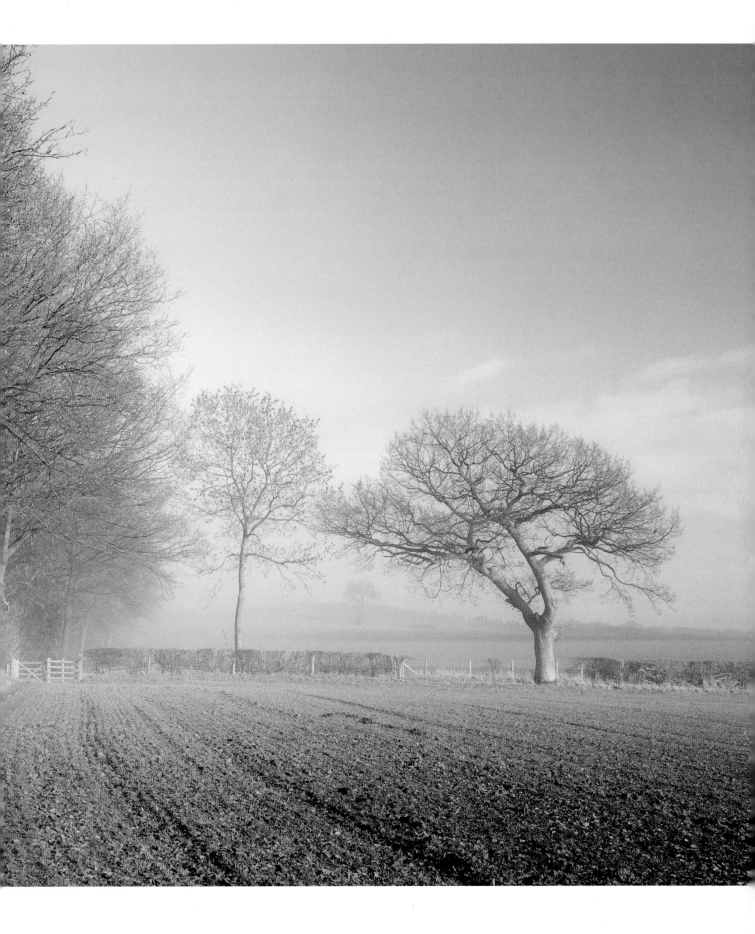

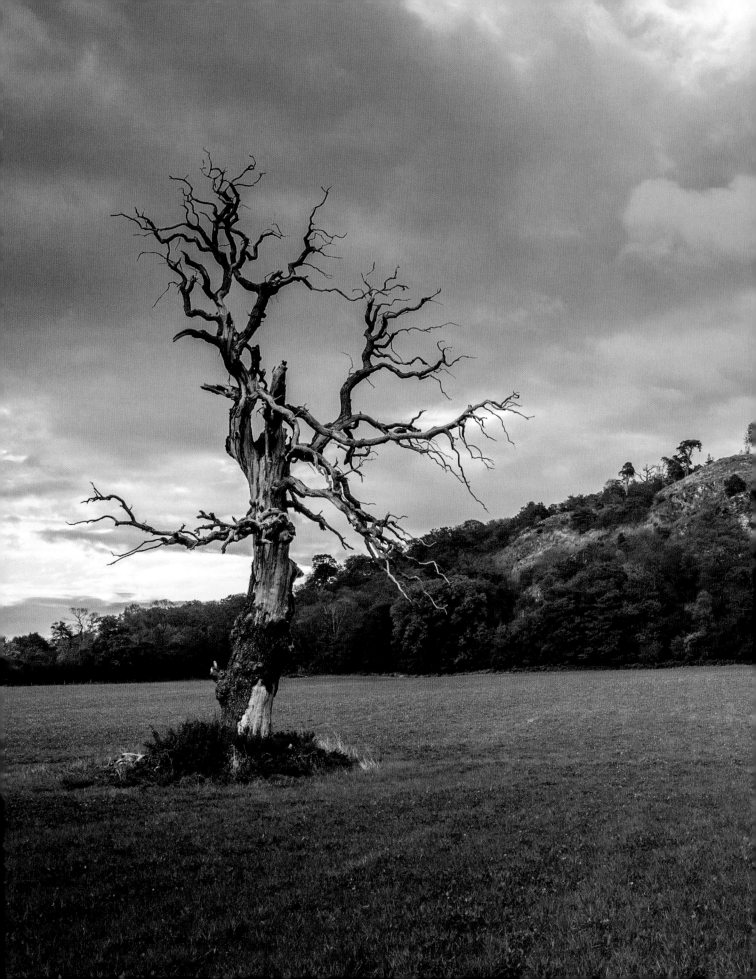

EDITH PARGETER

A Bloody Field by Shrewsbury

The passage of the arrow was like the flight of a bird, a strong vibration of wings and a vehement alighting. It pierced dinted breastplate and fine mail hauberk under, and drove clean into the heart he had deliberately exposed to assault. The sword slipped almost silently out of his relaxing hand, while he still sat erect and immovable, turned away from the combat he would not accept upon any terms. Then slowly, as it seemed, he leaned backwards towards the crupper of his horse, stiffly and solidly as a tree falls, and heeling to the right, perhaps drawn by the mere remaining impulse of the weight of his fallen sword, crashed from his saddle at the prince's feet.

The shifting tide of battle, ungovernable as the sea, had hung in balance only for an instant. It swayed again strongly, casting men lurching one against another. It caught up the king's raw, exultant shout of: "Henry Percy, slain! Henry Percy, slain!" and flung it echoing across the twilit, long-shadowed field, to be taken up and echoed as far as Haughmond hill, for a warning to all rebels:

"Henry Percy, slain! Henry Percy, slain!"

The Battle of Shrewsbury took place in 1403 between King Henry IV and the rebel Henry 'Harry Hotspur' Percy. When Hotspur fell in battle, his ally, the Earl of Douglas, fled but he was thrown from his horse on Haughmond Hill and was captured – the spot being known thereafter as Douglas's Leap.

A Bloody Field by Shrewsbury, published by Macmillan London Ltd, 1972

Photo: The field of the battle at Haughmond Hill, near Uffington

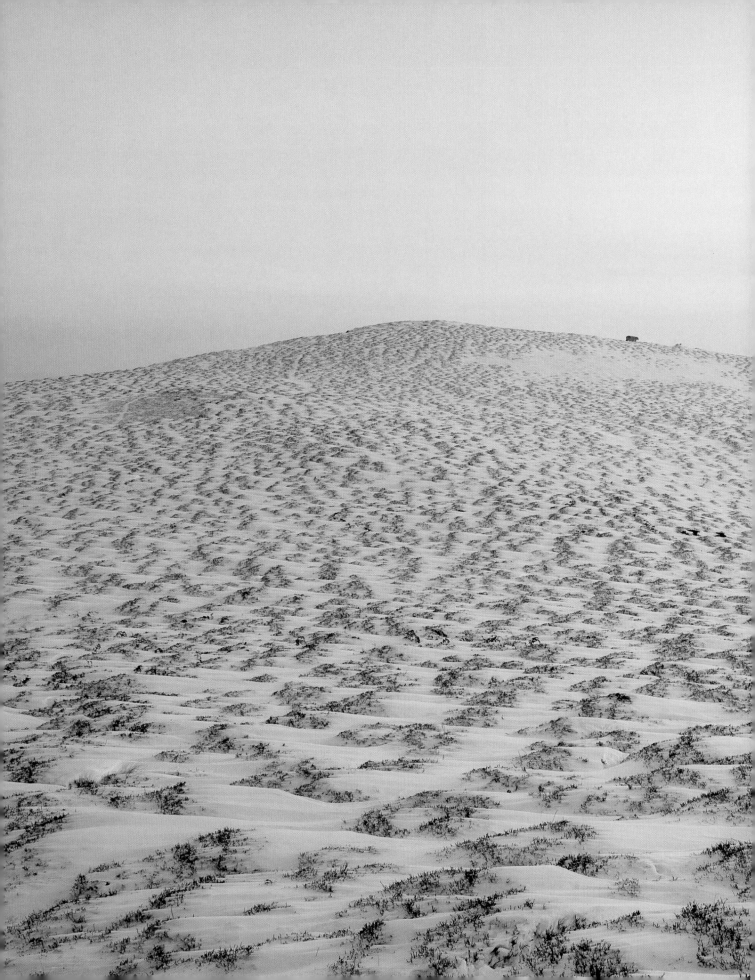

MIRABEL OSLER

The Rain Tree

Michael would get out his skis, and I'd saddle my horse, put a washing line round my waist and pull him up beyond the Nordy Bank, higher still, to the top of the Brown Clee Hill from where he could ski all the way home and I would return via lanes full of snow.

Mirabel Osler is a garden designer and writer who has written about her travels and her experiences of gardening in Shropshire. She lives in Ludlow.

The Rain Tree, Mirabel Osler, Bloomsbury, 2012 Photo: Packetstone Hill at dusk

PHIL RICKMAN

Smile of a Ghost

I don't know who or what it was, but I remember I did know, with a quite awful certainty, that something was going to happen as soon as I re-entered the chamber. Partly because of the cold – yes, I do know that's a cliché. But it wasn't a normal cold, not a healthy cold – not like rushing wind or crackling frost. It was a negativity, an absence, a hollowness… an area in which warmth couldn't exist.

She… it was… as I re-entered the chamber, there was a paleness. I can see it now, but I still can't properly describe it – only my own reactions to something that seemed to be made of nothing more than the cold air and the damp unfurling from the stone. I wasn't aware of a face, but I was sensing a horrible smile that was more like an absence of smile. A smile so cold, so bleak, so devoid of hope… only this perpetual, bitter… terminality.

A description from Phil Rickman's novel set in Ludlow of an encounter with the ghost of Marion de la Bruyère who, it is said, was betrayed by a young knight in the 12th century and threw herself from the Hanging Tower of Ludlow Castle.

Smile of a Ghost, Phil Rickman, published by Macmillan, 2005

Photo: Ludlow Castle, the north rampart of the Inner Bailey, viewed from the Castle Walk

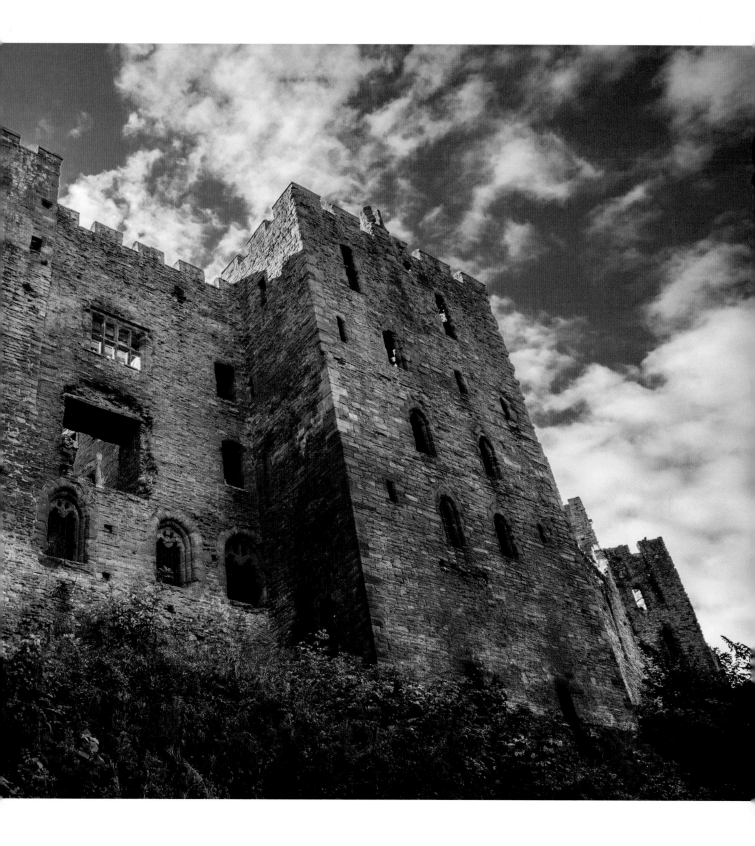

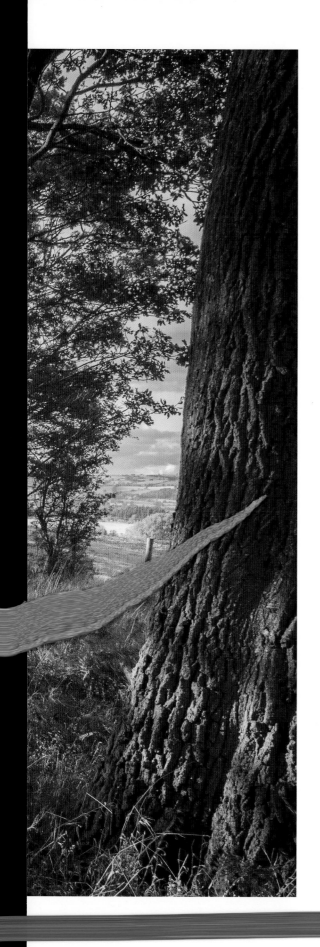

MARY WEBB

The House in Dormer Forest

Softly and slowly the fragrant evening fell around them. The plain slept, and over the rosy ploughlands, the quiet forest, the golden, ever-stirring wheat, were drawn thin, dusky veils. As the silence deepened, a thrush began to sing somewhere in the woods – an autumn thrush, more plaintive than those of spring. The music ascended like spirals of light smoke, and the soul that haunts the depths of the forest began to spin from itself the frail thread of beauty.

This novel centres on the relationships of the Darke family living uneasily in their gloomy oppressive country house. Written just after the Great War, Mary Webb questions the social values of the time and reflects some of the changes which were starting to occur. Although there is great emphasis on human relationships in this novel, the setting is hugely important as indicated by the fact that the first chapter describes the foreboding gothic air of Dormer Old House and its setting and the family characters are not introduced until the following chapter. Her Dormer Valley is actually Hope Valley near Snailbeach.

The House in Dormer Forest, Mary Webb, Hutchinson, London, 1920

Photo: Hope Valley forest, near Sn

LADY C. MILNES GASKELL

Spring in a Shropshire Abbey

"But you were telling me about your walk to the Wrekin, and how you drank from the Raven's and the Cuckoo's bowls there."

"Ay, ay, sure I was," replied the old man, and a gleam of light shot into his lustreless eyes. So saying he rubbed his hands softly before the blazing logs and went on –

"Well, it war the longest day of the year. That night in June, I've heard say, when they used to light fires on the hill tops, and when the men used to sing, and some of 'em used to leap through the fires and call it Johnnie's Watch; but the squires, when they took to planting on the hillsides, forbid that sport, and there war somethin' to be said on that score, for I believe myself it frightened foxes.

"Well, sure enough I walked, as I said, to the Wrekin over the Severn by Buildwas Bridge, and up beyond near Little Wenlock and through Wenlock Wood. I war desperate sweet on Susie Langford – I hadn't hardly opened my mouth to her, but the sight of her remained with me, night and day, same as the form of a good horse does to a young man who can't afford to buy him – and I stood on the heights of the great hill, and I drank out of the bowls and wished and wished, and made sure as I should get my heart's desire, for grandam had allus said, 'Him as goes to the Wrekin on midsummer morning, gains his wish as sure as a throstle catches a worm on May morning.' Them, her used to say, 'as goes to the Wrekin on the May Wakes, gets nought but a jug of ale and a cake.' Well, I think I got nought but water, and never a cake that mornin' for little the wish or the bowls did for me."

After her marriage to the barrister Gerald Milnes Gaskell in 1876, Lady Catherine Milnes Gaskell lived at Wenlock Abbey. Their many artistic and literary visitors included the American novelist Henry James and Thomas Hardy.

Spring in a Shropshire Abbey, published by Smith, Elder & Co, London, 1905

Photo: Diamond Jubilee beacon on Caer Caradoc, 4 June 2012

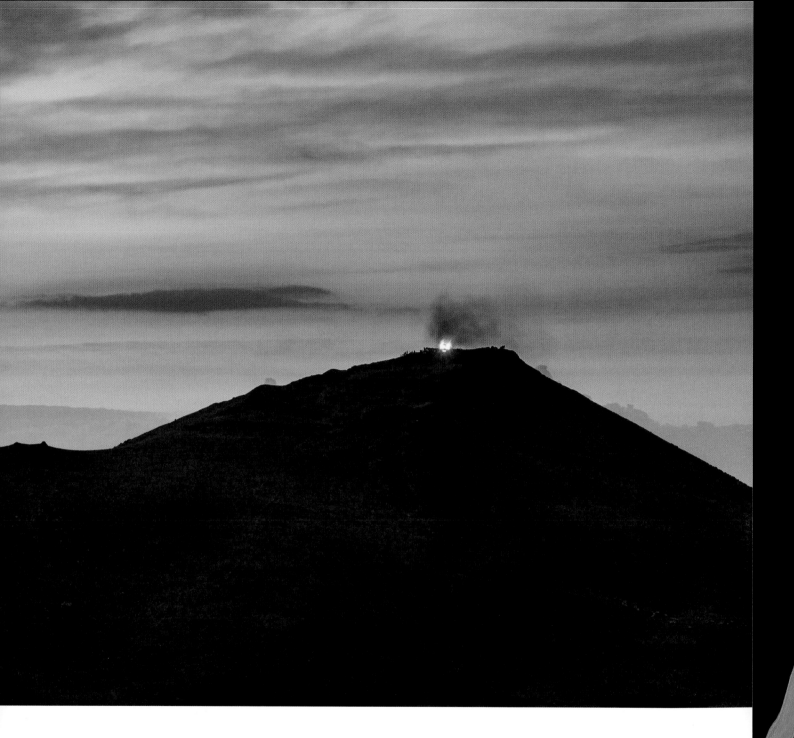

*Near the summit of The Wrekin is a natural hollow
called the Raven's Bowl or the Cuckoo's Cup which
is always full of water and it is believed all visitors
should drink from it. The Wrekin Wakes were held
on the first Sunday in May and three successive
Sundays when there would be large crowds enjoying
ale, gingerbread, fairground attractions and a
day-long battle between colliers and countrymen for
possession of the hill.*

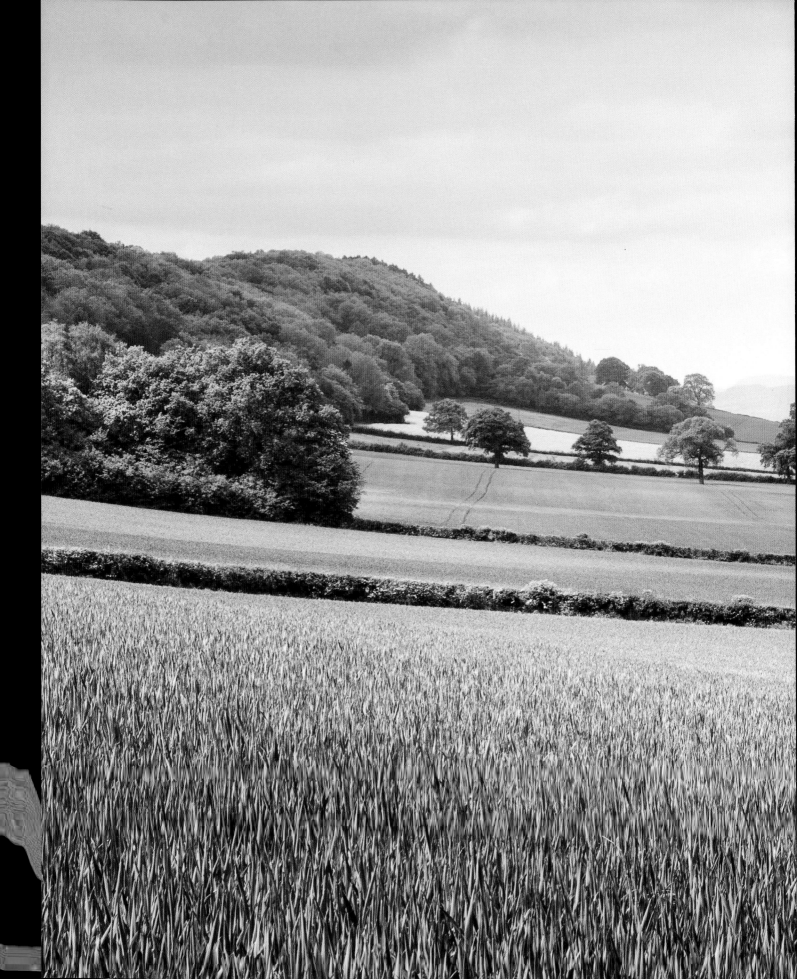

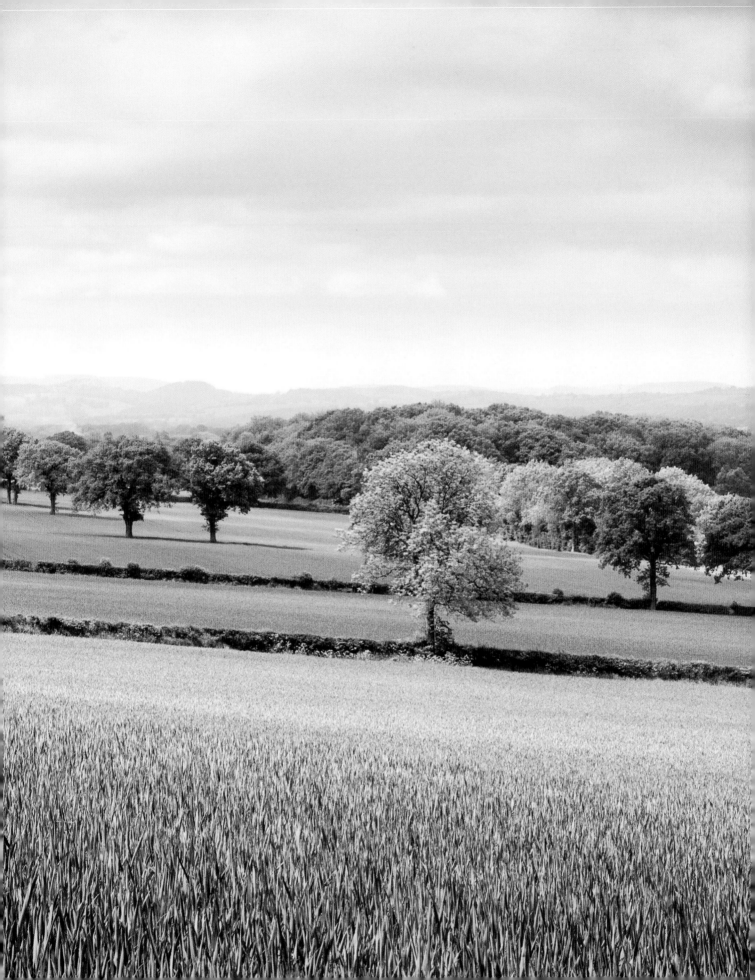

JOHN MILTON

Song to Sabrina

Sabrina fair,
Listen where thou art sitting
Under the glassy, cool, translucent wave,
In twisted braids of lilies knitting
The loose train of thy amber-dropping hair;
Listen for dear honour's sake,
Goddess of the silver lake,
Listen and save.

Sabrina rises, attended by water-nymphs and sings

By the rushy-fringed bank,
Where grow the willow and the osier dank,
My sliding chariot stays,
Thick set with agate and the azure sheen
Of turquoise blue, and emerald green,
That in the channel strays;
Whilst from off the waters fleet
Thus I set my printless feet
O'er the cowslip's velvet head,
That bends not as I tread;
Gentle swain, at thy request,
I am here.

Although it is not thought that John Milton ever visited Shropshire, his Masque 'Comus' was first performed in the Council Chamber of Ludlow Castle for the President of the Council of the Marches, the Earl of Bridgewater, in 1634. This grand, dramatic entertainment was recreated in 1934, and again in 1984 as part of the Ludlow Festival.

From *Comus*: A Masque presented at Ludlow Castle (1634) before the Earl of Bridgewater, Lord President of Wales, John Milton (1608–1674)

Photo: Willows by the English Bridge spanning the Severn at Shrewsbury

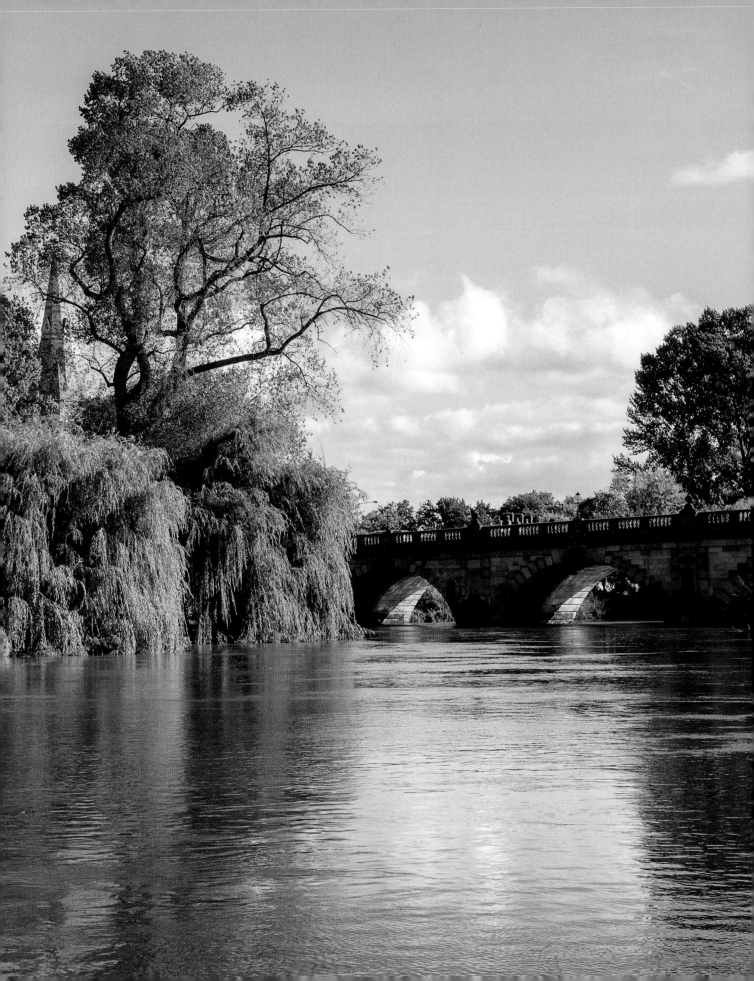

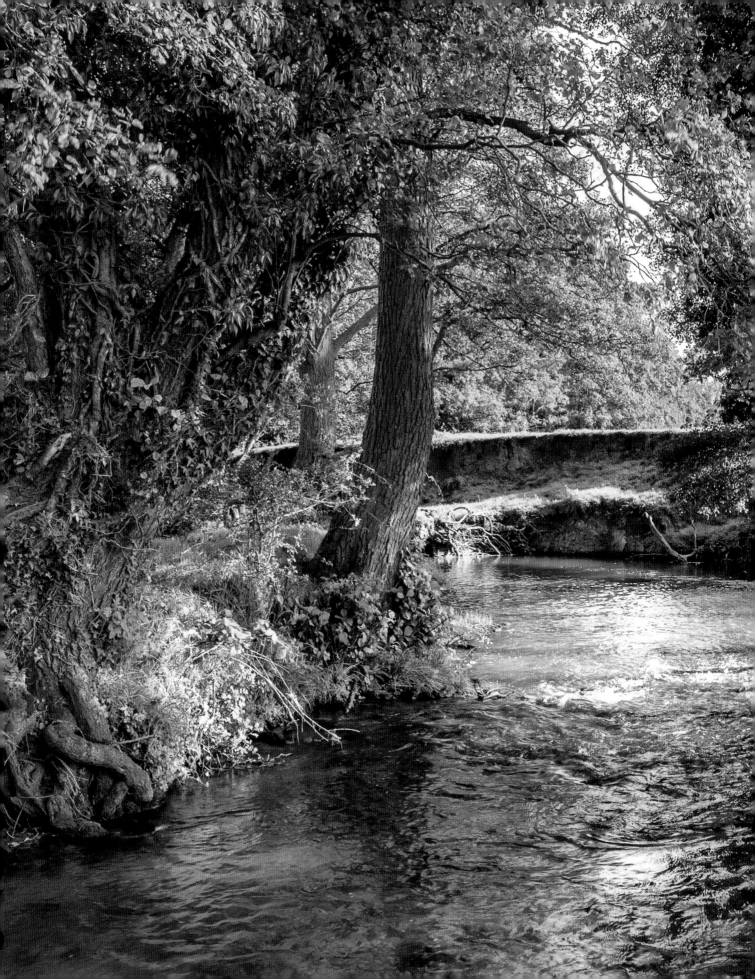

LAURENCE CATLOW

Once a Flyfisher

The Rea is a secret river, a little vein of wildness twisting through the farmlands, below its high steep banks. These banks are full of stings and pricks and tangles, full of nettles and thistles and bindweed; and from them rise ancient alders and gnarled willows and huge black poplars. The Rea is a river of shadows, of brown water and red clay. It is a brook rather than a river. Fishing it today, while the wind roared in the tree tops and sent broken twigs splashing down onto the water, fishing it today I felt that, whatever I have written elsewhere in this diary, I was fishing my way back to childhood, and that, if only I fished long and far enough, I should find myself again in the world where I roamed so carelessly as a boy, more often without than with a fishing rod, a world of birds' nests and lapwings' eggs, of fabled fish living in forbidden pools, of enthusiasms that seemed all-consuming and were themselves consumed within a week: a world of wonder and mystery and of immortality.

Fishing and shooting author Laurence Catlow was Head of Classics at Sedbergh School in Cumbria until 2011. He loves to fish the Shropshire rivers on his frequent visits to stay with close friends in Ludlow.

Once a Flyfisher, published by Merlin Unwin Books, 2001

Photo: A bend in the river Rea, at Hinton, near Stottesdon

TOM SHARPE

Blott on the Landscape

Now as he drove northwards he had to admit that he was entering a world far removed from his ideal. Even the sky had changed with the landscape and the shadows of large clouds slid erratically across the fields and hills. By the time he reached South Worfordshire he was distinctly perturbed. If Worford was anything like the surrounding countryside it must be a horrid place filled with violent, irrational creatures swayed by strange emotions. It was. As he drove over the bridge that spanned the Cleene he seemed to have moved out of the twentieth century into an earlier age. The houses below the town gate were huddled together higgledy-piggledy and only their scrubbed doorsteps redeemed their squalid lack of uniformity. The gate, a great stuccoed tower with a dark narrow entrance, loomed up before him. He drove nervously through and emerged into a street lined with eighteenth-century houses. Here he felt temporarily more at home but his relief evaporated when he reached the town centre. Dark narrow alleyways, half-timbered medieval houses jutting over the pavement, cobbled streets, and shopfronts which retained the format of an earlier age. Pots and pans, spades and sickles hung outside an ironmonger's. Duffel coats, corduroy trousers and breeches were displayed outside an outfitter's. A mackerel gleamed on a fishmonger's marble slab while a saddler's was adorned with bits and bridles and leather belts. Worford was in short a perfectly normal market town but to Dundridge, accustomed to the soothing anonymity of supermarkets, there was a disturbing, archaic quality about it.

The 1985 TV series of Blott on the Landscape was filmed around Ludlow which was used for the fictitious town of Worford. Dundridge, the man from the ministry, has come to placate the locals over the proposed construction of a motorway through Cleene Gorge and finds his surroundings unnerving.

Blott on the Landscape, first published 1975 by Martin Secker & Warburg Ltd. 1996 edition by Pan Books, Macmillan Publishers Ltd, London.

Photo: Looking east along Market Street, Ludlow

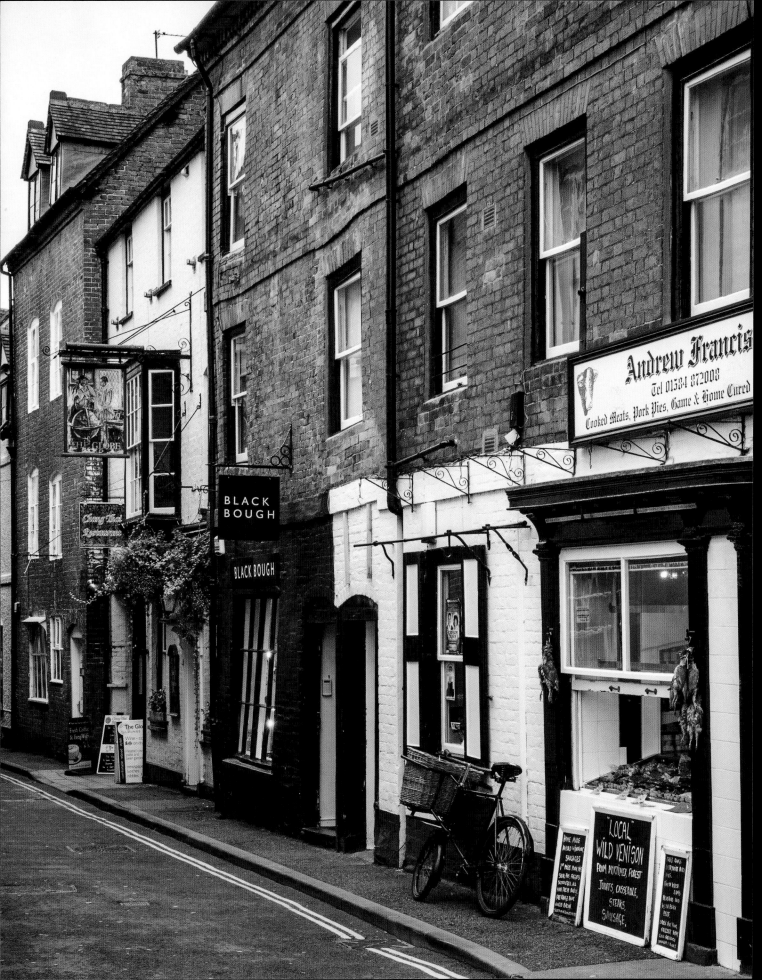

C. W. SHEPHERD

The Crooked Spire

The church of Cleobury is grey
With centuries long passed away.
Its added spire is all awry,
But nobody can tell you why.
Some say it's what the rain has done,
Whilst others vow it was the sun.
Elijah Logg, the sexton man,
Declares 'twas bent when it began,
From crooked ways to warn the people
Living round the crooked steeple.
A parson, though, by name of Childers,
Swears the reason was bad builders.

But be it bent by what it may,
It rears its wooden height to-day;
And folk as far away as Rock
Can see its brassy weather-cock
Like polished gold when morning rays
Glint upon it slanting-ways.

This is quoted at the start of Simon Evans' book, Shropshire Days and Shropshire Ways.

Shropshire Days and Shropshire Ways, published by Heath Cranton Ltd, London, 1938

Photo: The crooked spire of St Mary's, Cleobury Mortimer

PAUL EVANS

Bury Ditches Hill Fort

The big days burned themselves out. Startled by their own reflections, the days of burning sunshine, brilliant skies and hot still air, which somehow drifted here like fabulous but ephemeral creatures, turned and fled. Before they did, the heat built to a climate no one had felt this summer and certainly never known in October. People seemed possessed by a new spirit of holiday which rose against autumnal melancholy, played outdoors with children, walked with bounce and swagger, picnicked as rooks yelled into the dusk and roosted with the windows open. "If only we had more of this, if only …"

Those days left behind them a morning of curious, silver-blue patterns like the wing marks of huge migrating butterflies in the sky and a diaphanous mist to veil the valleys. It was a strange leaving. The swallows had gone, the harvest was in, the season changed, yet some rogue dream of summer was left by those days, or so it seemed on Sunnyhill. One of the misty folded hills of the Welsh Marches, it has a wonderfully intact hill fort of earthworks called the Bury Ditches on top of it. The sky was piled with cloud but the elliptical banks and ditches held a soft warmth in their shales.

Young hollies, returned after gales blew down the conifer plantation, were crammed with red berries. A band of long-tailed tits zipped across the open acres of tawny grass and cropped heather. The earthworks spoke of enclosure – a keeping, in and out, of secret things. The fleshy red and white-spotted fly agaric fungi spoke of old birch woods; the grey lichen of an ancient heath. A field grasshopper stretched its legs as if to sing but thought better of it. Silence now, breeze in trees, leaves will fall.

Paul Evans writes a regular nature diary, usually about the area around Wenlock Edge, for The Guardian. *The Bury Ditches hillfort, near Lydbury North, dates from the 1st millennium BC and is considered to be one of the finest hillforts in Britain.*

Published in *The Guardian* (Country Diary), 4 October 2011

Photo: Bury Ditches looking east, 6 October 2012

42

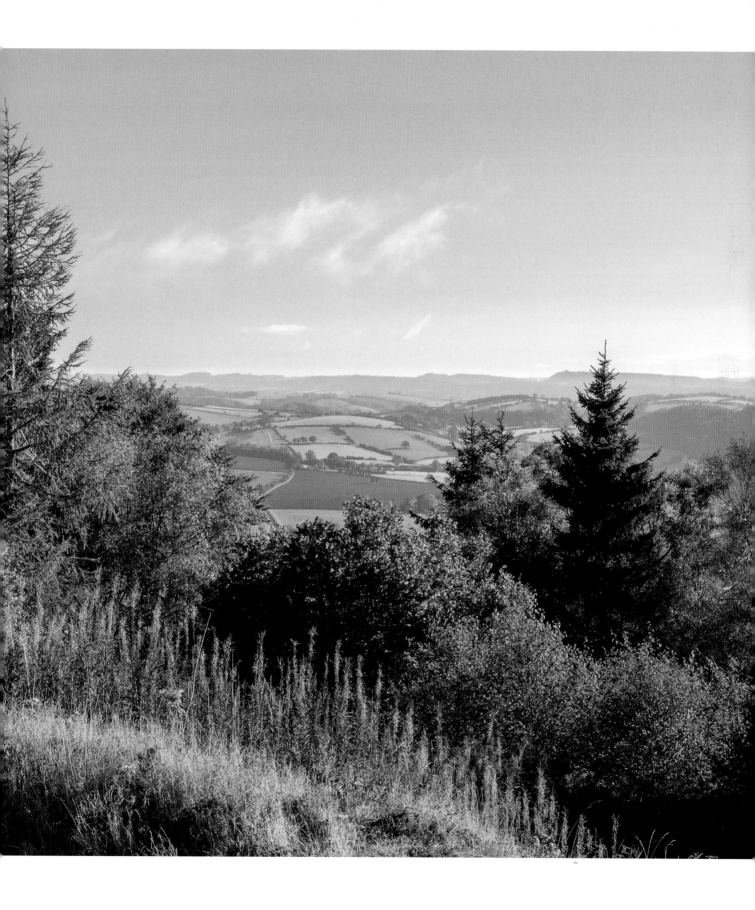

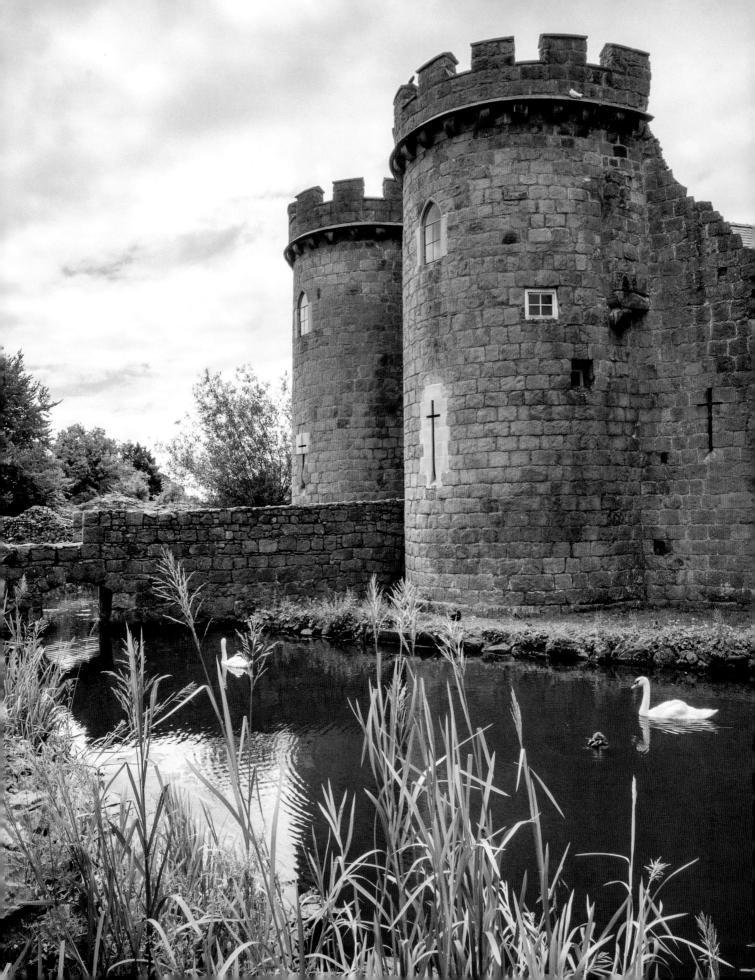

JOHN F. M. DOVASTON

The Ruins of Whittington Castle

Oh, Whittington, amongst thy tow'rs,
　Pleased did my early childhood stray,
Bask'd on thy walls in sunny hours,
And pull'd thy moss, and pluck'd thy flowers,
　Fully many a truant day.
And midst the weed-bewilder'd ways
I've thought on Giants, Hags and Fays,
Or aught that in those elfish days
　My eager eye hath read;
And hying home at evening tide,
Scared if the circling bat I spied,
I've pass'd in haste thy portals wide
　With no unpleasing dread.

This is from Fitz-Gwarine, A Ballad of the Welsh Border; in Three Cantos. John F. M Dovaston (1782-1854) lived at The Nursery, Wsst Felton and was a poet and naturalist.

Fitz-Gwarine, A Ballad of the Welsh Border, published by Longman, Hurst, Rees, Orme and Brown, London 1816

Photo: Gatehouse to Whittington Castle, near Oswestry

SIMON EVANS

Shropshire Days and Shropshire Ways

Across the glades between the woods the laughing green-backed woodpeckers shout aloud; it is as if they are swept in joyous swoops by some unseen power over airy switchbacks. But it is that strange, wary bird the curlew which moves me most of all. It is found only in the lonely quiet places, its flight is all smooth grace, its call is a long linked-up trill of silver notes, sweet, plaintive, rising, rising, then, slowly – ah – so slowly, falling – falling – full and piercing sweet. The curlew's flight is dignified and perfectly controlled, as it sweeps down each note becomes longer, vibrates, and then falls into a lower key until it becomes indescribably soft, then, as the bird disappears in the long lush grass of Moor Brook Meadows, the sweet notes fade away and all seems strangely still.

Nothing tugs so much at my heart-strings, nothing fills the air with such plaintive sweetness as the curlews do when they sweep and float and glide over the long brook meadows, calling – calling – rising – falling –

Simon Evans lived in Cleobury Mortimer in the 1930s and worked as a postman. He had been wounded and gassed in WW1 and moved to Shropshire in the hope that the country air would help him recuperate. He walked about 18 miles each day and wrote about his rural life. There is a walk based on his round starting in Cleobury Mortimer.

Shropshire Days and Shropshire Ways, published by Heath Cranton Ltd, London, 1938

Photo: Duddlewick, near Moor Brook Meadows

WILFRED OWEN

Uriconium – An Ode

It lieth low near merry England's heart
Like a long-buried sin; and Englishmen
Forget that in its death their sires had part.
And, like a sin, Time lays it bare again
 To tell of races wronged,
And ancient glories suddenly overcast,
And treasures flung to fire and rabble wrath.
 If thou hast ever longed
To lift the gloomy curtain of Time Past,
And spy the secret things that Hades hath,
Here through this riven ground take such a view.
The dust, that fell unnoted as a dew,
Wrapped the dead city's face like mummy-cloth:
All is as was: except for worm and moth.

Since Jove was worshipped under Wrekin's shade
Or Latin phrase was writ in Shropshire stone,
Since Druid chaunts desponded in this glade
Or Tuscan general called that field his own,
 How long ago? How long?

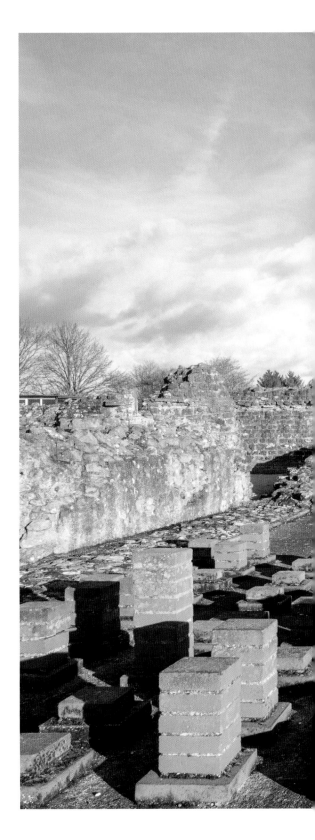

Wilfred Owen was fascinated with the remains of the Roman city at Wroxeter and this is the opening of his poem written in 1913 when he was 20.

The War Poems of Wilfred Owen, Edited and Introduced by Jon Stallworthy, published by Chatto & Windus, London 1994

Photo: The ruins of Viriconium's public baths and hypocaust at Wroxeter, near Shrewsbury

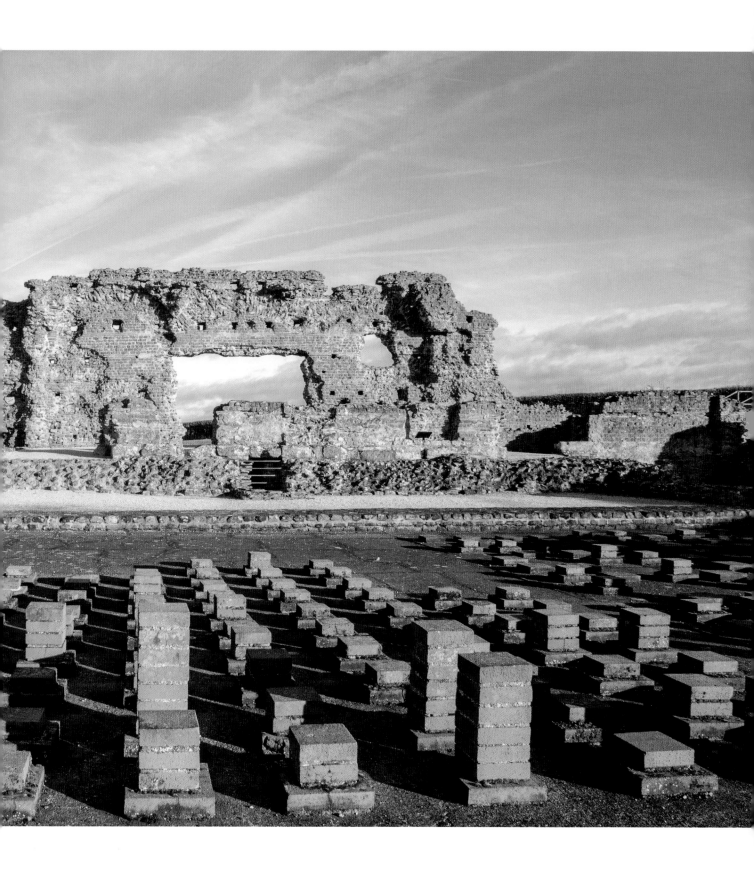

MARY WEBB

Presences

There is a presence on the lonely hill,
Lovely and chill:
There is an emanation in the wood,
Half understood.
They come upon me like an evening cloud,
Stranger than moon-rise, whiter than a shroud.
I shall not see them plain
Ever again,
Though in my childhood days
I knew their ways.
They are as secret as the black cloud-shadows
Sliding along the ripe midsummer grass;
With a breath-taking majesty they pass
Down by the water in the mournful meadows;
Out of the pale pink distance at the falling
Of dusk they gaze – remote, summoning, chill;
Sweetly in April I have heard them calling
Where through black ash-buds gleams the purple hill.

*This was written when Mary Webb was living at Lyth Hill
with her husband. She was inspired by the views from their
cottage of the Shropshire hills.*

Selected Poems of Mary Webb, edited by Gladys Mary Coles,
published by Headland Publications, 2005

Photo: Wenlock Edge, above Middlehope

HESBA STRETTON

Fern's Hollow

The middle weeks of August were come – sunny, sultry weeks; and from the brow of the hill, all the vast plain lying westward for many miles looked golden with the corn ripening for harvest. The oats in the little field had already been reaped; and the fruit in the garden, gathered and sold by Martha, had brought in a few shillings, which were carefully hoarded up to buy winter clothing. It was now the time of the yearly gathering of bilberries on the hills; and tribes of women and children ascended to the tableland from all the villages round. It was the pleasantest work of the year; and Martha, who had never missed the bilberry season since she could remember, was not likely to miss it now. Even little Nan could help to pick the berries, and she and Martha were out on the hillsides all the livelong summer day.

Sarah Smith (1832-1911) was born in Wellington. Her father had a bookshop and printed evangelical fiction. Her pseudonym came from the initials of her siblings and Stretton from All Stretton which she visited as a child. She had over 50 books published, mostly short, very religious stories. Many highlighted the plight of impoverished children on the streets of Victorian London and she helped to found what later became the NSPCC.

Fern's Hollow, published by The Religious Tract Society, London

Photo: Asterton Prolley Moor from The Long Mynd

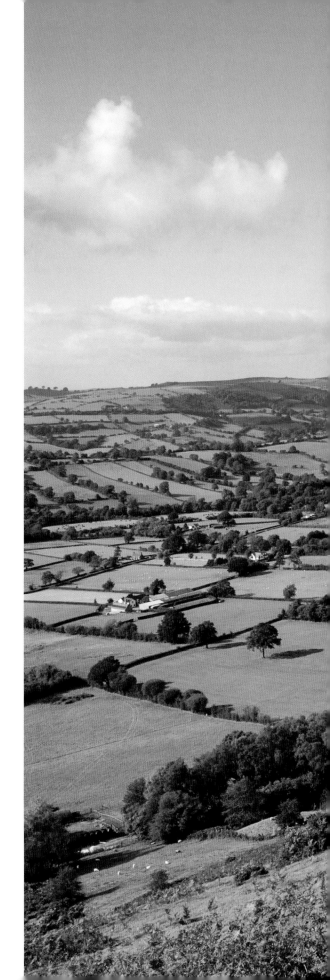

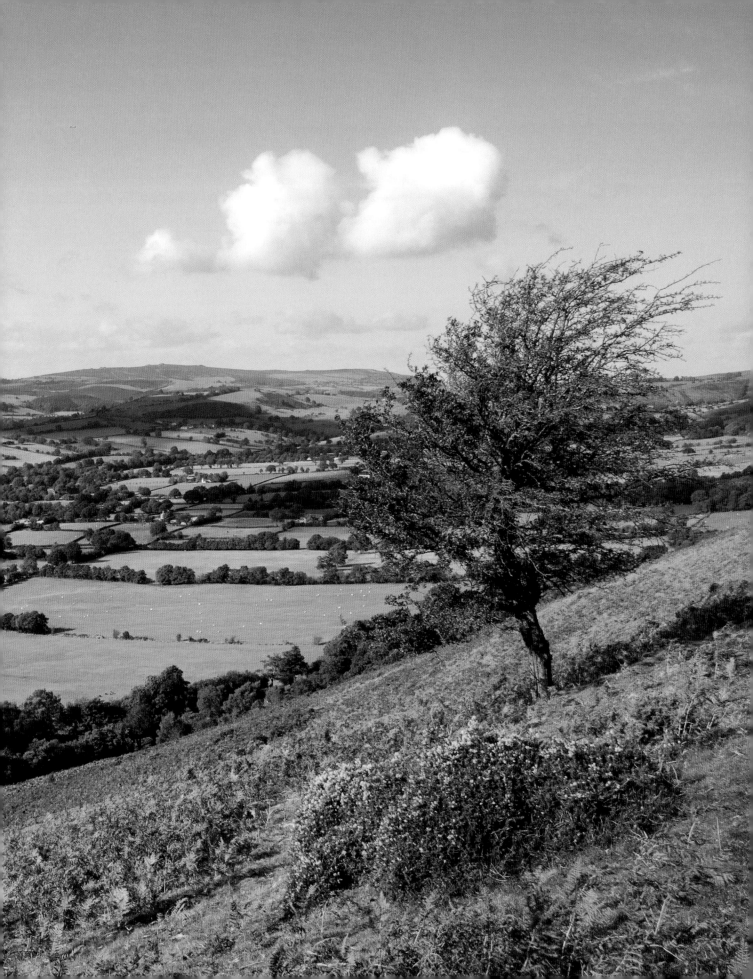

OSWALD FEILDEN

The Legend of Ellesmere

I've heard it said, where now so clear
The water of that silver mere,
 It once was all dry ground;
And on a gentle eminence,
A cottage with a garden fence,
 Which hedged it all around.

And there resided all alone,
So runs the tale, an aged crone,
 A witch, as some folks thought.
And to her home a well was near,
Whose waters were so bright and clear
 By many it was sought.

But greatly it displeased the dame
To see how all her neighbours came
 Her cool, clear spring to use.
And often she was heard to say
That if they came another day,
 She would the well refuse.

"Upon this little hill," said she,
"My house I built for privacy,
 Which now I see in vain:
For day by day yon people come
Thronging in crowds around my home,
 This water to obtain."

But when folks laughed at what she said,
Here caught, - with passion red,
 She uttered this dreadful curse :
"Ye neighbours one and all beware!
If here to come again you dare
 For you 'twill be the worse!"

Of these her words they took no heed,
And when of water they had need
 Next day, they came again.
The dame they found was not at home,
The well was locked, - so they had come
 Their journey all in vain.

The well was safely locked. But though
You might with bolts and bars, you know,
 Prevent the water going,
One thing, forsooth, could not be done,
I mean, forbid the spring to run
 And stop it overflowing.

It flowed on gently all next day,
And soon around the well there lay
 A pond of water clear,
And as it ever gathered strength,
It deeper grew, until at length
 The pond became a mere.

To some, alas! The flood brought death;
Full many cottage lies beneath
 The waters of the lake;
And those who dwelt on either side
Were driven by the rising tide
 Their homesteads to forsake.

And all that day, as none could draw,
The water rose full two feet more
 Than ever had been known :
And when the evening shadows fell,
Beneath the cover of the well
 A stream was running down.

And as they fled, that parting word
Which they so heedlessly had heard,
 They now recalled, I ween!
The dame was gone; but where once stood
The cottage, still above the flood,
 An island may be seen.

*The legend of how the great mere at Ellesmere came
to be was put into verse by Rev. Oswald M. Feilden.
He was Rector of West Frankton, near Ellesmere,
from 1865 to his death in 1924.*

Shropshire in Poem and Legend, Michael Peele, published
by Wilding and Son Ltd, Shrewsbury, 1923

Photo: The Mere at Ellesmere.

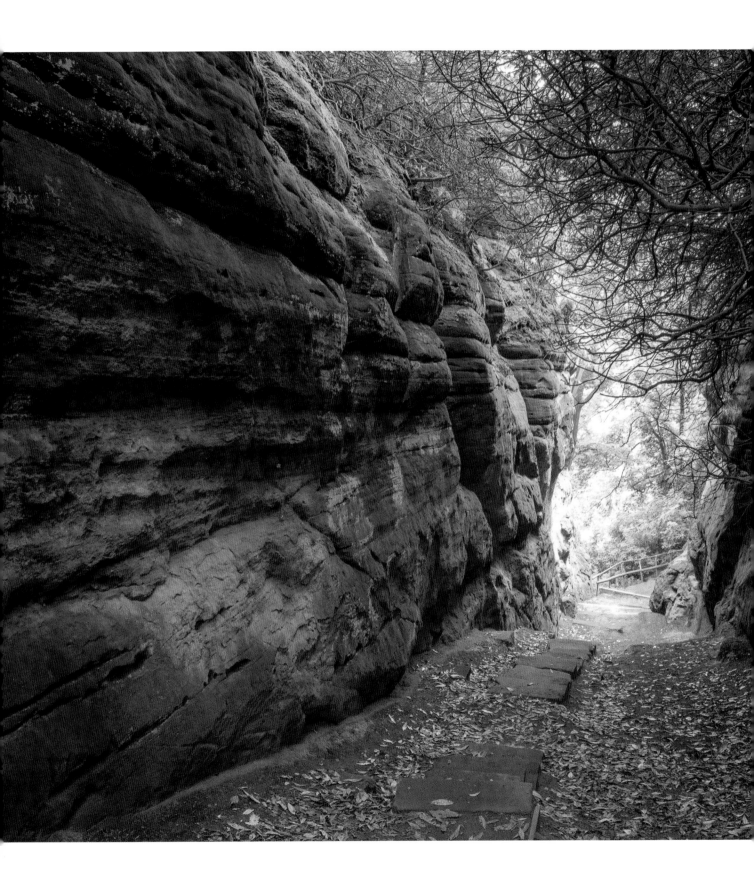

JAMES BOSWELL

The Life of Samuel Johnson

We saw Hawkestone, the seat of Sir Rowland Hill, and were conducted by Miss Hill over a large tract of rocks and woods; a region abounding with striking scenes and terrifick grandeur. We were always on the brink of a precipice, or at the foot of a lofty rock; but the steeps were seldom naked; in many places, oaks of uncommon magnitude shot up from the crannies of stone; and where there were not tall trees, there were underwoods and bushes.

Round the rocks is a narrow patch cut upon the stone, which is very frequently hewn into steps; but art has proceeded no further than to make the succession of wonders safely accessible. The whole circuit is somewhat laborious; it is terminated by a grotto cut in a rock to a great extent, with many windings, and supported by pillars, not hewn in regularity, but such as imitate the sports of nature, by asperities and protuberances.

The place is without any dampness, and would afford an habitation not uncomfortable. There were from space to space seats in the rock. Though it wants water, it excels Dovedale by the extent of its prospects, the awfulness of its shades, the horrors of its precipices, the verdures of its hollows, and the loftiness of its rocks. The ideas which it forces upon the mind are the sublime, the dreadful and the vast. Above, is inaccessible altitude, below, is horrible profundity.

Dr Johnson seems to have been extremely impressed with Hawkstone Park when he called there on his way to North Wales in July 1774.

Extract from *The Life of Samuel Johnson*, James Boswell, 1791

Photo: Ravine leading to Grotto Hill, Hawkstone Park

57

BILL BRYSON

Notes from a Small Island

Ludlow was indeed a charming and agreeable place on a hilltop high above the River Teme. It appeared to have everything you could want in a community - bookshops, a cinema, some appealing-looking tearooms and bakeries, a couple of 'family butchers' (I always want to go in and say, 'How much to do mine?'), an old-fashioned Woolworth's and the usual assortment of chemists, pubs, haberdashers and the like, all neatly arrayed and respectful of their surroundings. The Ludlow Civic Society had thoughtfully put plaques up on many of the buildings announcing who had once lived there. One such hung on the wall of the Angel, an old coaching inn on Broad Street now sadly - and I hoped only temporarily - boarded up. According to the plaque, the famous Aurora coach once covered the hundred or so miles to London in just over twenty-seven hours, which just shows you how much we've progressed. Now British Rail could probably do it in half the time.

Nearby I chanced upon the headquarters of an organization called the Ludlow and District Cats Protection League, which intrigued me. Whatever, I wondered, did the people of Ludlow do to their cats that required the setting up of a special protective agency? Perhaps I'm coming at this from the wrong angle, but short of setting cats alight and actually throwing them at me, I can't think of what you would have to do to drive me to set up a charity to defend their interests. It seemed extraordinary to me that there could be a whole, clearly well-funded office dedicated just to the safety and well-being of Ludlow and District cats. I was no less intrigued by the curiously specific limits of the society's self-imposed remit - the idea that they were interested only in the safety and well-being of Ludlow and District cats.

What would happen, I wondered, if the members of the league found you teasing a cat just outside the district boundaries? Would they shrug resignedly and say, 'Out of our jurisdiction'? Who can say?

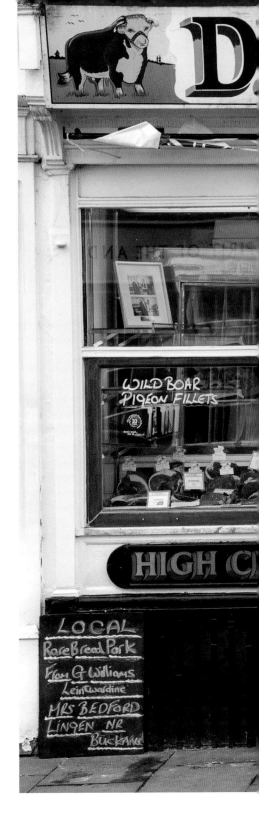

58

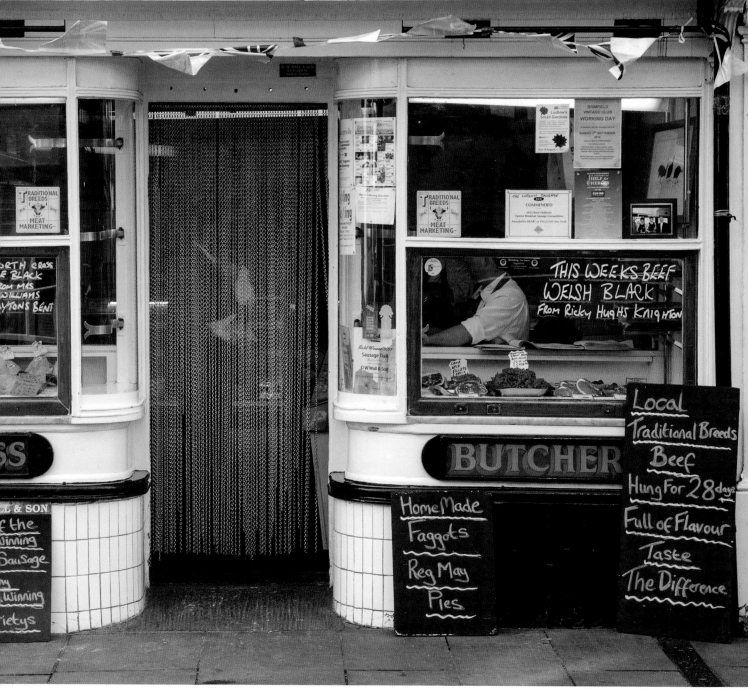

Photo: Family butchers D.W. Wall & Sons, High Street, Ludlow

Bill Bryson had been living in England for 20 years and decided to move back to USA. He took what he thought was one last trip around UK and *Notes from a Small Island* was the result. However, he has now moved back to England again!

Notes from a Small Island (Chapter 22) Bill Bryson, published by HarperCollins, 1995

JOHN MASEFIELD

The Curlews

We three were in wild Shropshire, picking sloes,
Shropshire where Wrekin stands and Severn flows,
Fortune had set glad feathers in our caps,
After fierce storms, hot tropics and ill-haps.
And who can tell aright the joy we felt
There, in that happy chance by Fortune dealt?

In the red west, the sun was sinking low,
With baskets full of sloes we turned to go,
But paused, to watch the light on waste and pond
Put colour on the hills in Wales beyond,
And heard the church bells tell the time afar
Above dim graves wherein our kinsmen are.

And looking at that Shropshire scene I cried,
'No sunset sees a lovelier country-side:
This waste of sloes; the cornfield with its stooks,
The last sun on the elms, with the last rooks,
What would improve such beauty; nay what could?'
My great friend said, 'Some birds might… curlews would.'

And at her word a cry of curlews came,
Crying their cry of creatures never tame,
That marvellous cry that birds make out of breath
Whose marvellous meaning we may know at death.
This, like her lovely spirit, made us know,
All the scene's soul, that had been only show.

*John Masefield (1878-1967) was appointed Poet Laureate in 1930
and held this post until his death. Although known to many for his
poems about the sea, he spent his childhood roaming the countryside
around his Ledbury home and described this area as his 'Paradise'.*

The Curlews, John Masefield, published by William Heinemann Ltd,
1967

Photo: The Wrekin from Harnage, looking across the River
Severn.

MARY WEBB

In Dark Weather

Against the gaunt, brown-purple hill
The bright brown oak is wide and bare;
A pale-brown flock is feeding there –
 Contented, still.

No bracken lights the bleak hill-side;
No leaves are on the branches wide;
No lambs across the fields have cried;
 - Not yet.

But whorl by whorl the green fronds climb;
The ewes are patient till their time;
The warm buds swell beneath the rime –
 For life does not forget.

*As a child, Mary Webb (born Mary Gladys Meredith) lived at
The Grange, Much Wenlock, not far from here. She was taught
by her father who nurtured both her love of literature and of
the countryside around their home.*

Selected Poems of Mary Webb, edited by Gladys Mary Coles,
published by Headland Publications, West Kirby, Wirral, 2005

Photo: Ewes at Manor Farm, Easthope

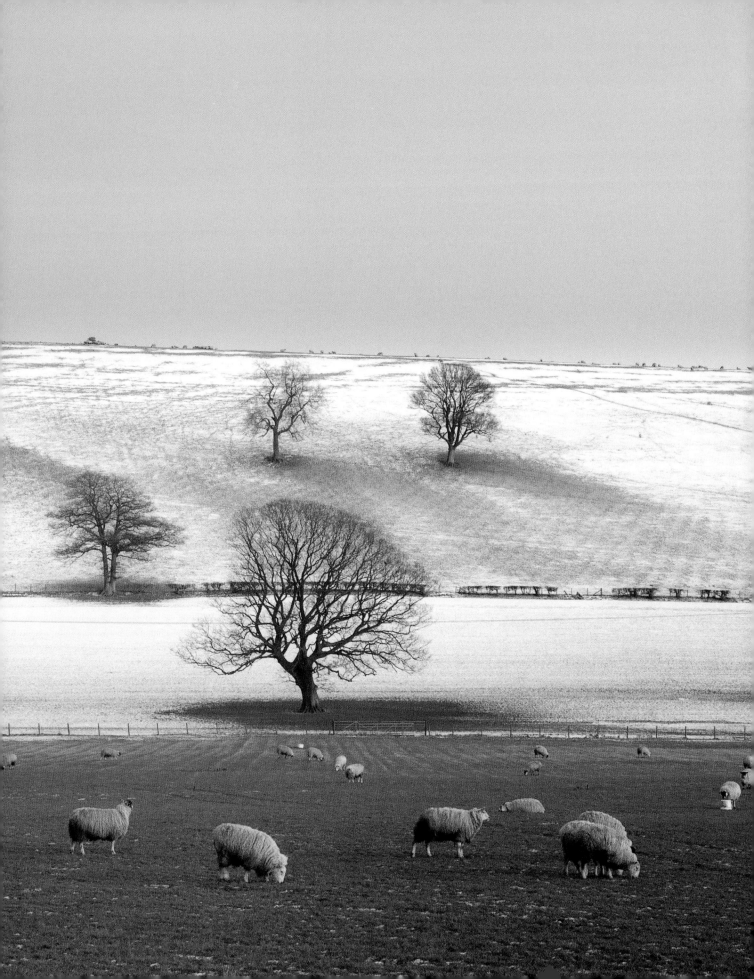

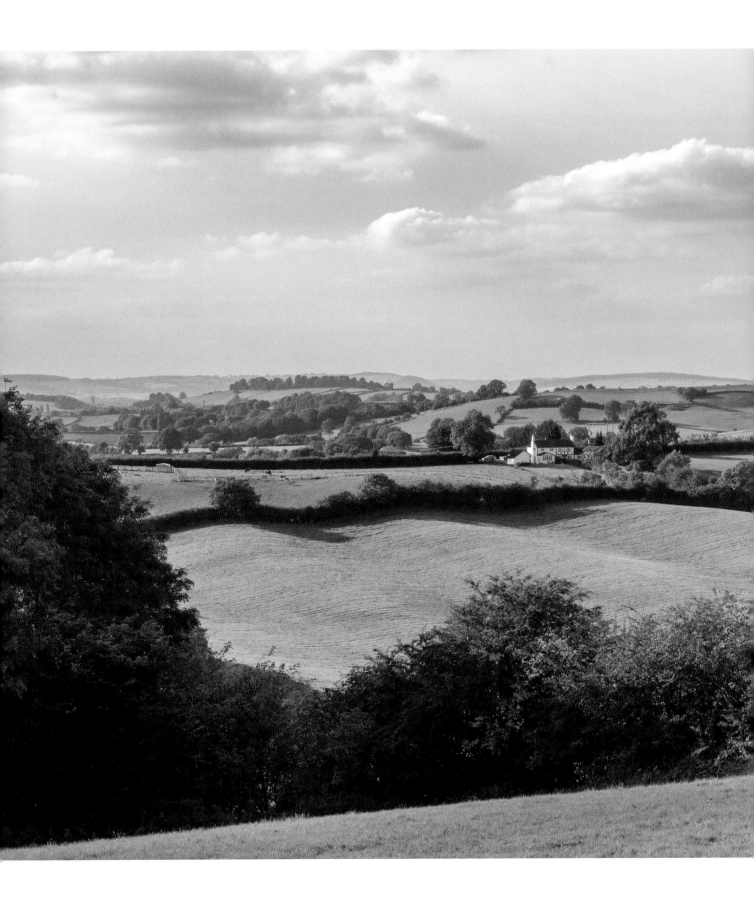

PETER DAVIS

The Diary of a Shropshire Farmer

February 7, 1836

Small frost. Mr & Mrs H Davis and Mr Trumper come here (the Park) to Tea and taste Miss Reynolds Piclets. She being famous for making prime ones as indeed she is for doing everything else in the way of cookery &c. They stay supper. We play at whist, myself being most singularly unfortunate losing more than I ever did in one evening before at the game viz about £4. So much for gaming. However there's one consolation – if one did not sometimes see and feel the evil consequences of vice the practice of virtue would not appear so delightful.

September 26, 1837

Dry, cold east wind in the morning. Fine and very warm afterwards. Finish hop picking. Give the pickers their dinner of Plum pudding and Mutton Pasty. Being so fine a day we lay the Tables in the green before the house and all seemed delighted with the entertainment.

Peter Davis' diaries are edited by one of his great great grandsons and describe his daily life farming at Dean Park, Burford.

Diary of a Shropshire Farmer: A Young Yeoman's Life and Travels 1835-37, Peter Davis, edited by Martin Davis, published by Amberley Publishing, Stroud

Photo: Dean Park, Burford, near Tenbury Wells

NORMAN & MARY BALDWIN

Wenlock Edge

Storm clouds, ink filled,
ominous and creeping slow,
drop veil on veil of wet grey gauze
before the distant hills; but still
some pools of sunshine, islanded,
float fast before the coming storm,
and then are lost – as is a spoken word
blown skyward by a tearing wind –
and peaceful vale is changed
to a field of elemental battle
by arrowing rain fought fierce,
while angry disputatious thunder
drums in wild applause.
The battle ceases
trailing quiet in its wake.
The floating pools of gold return
to the peaceful valley floor,
floodlit with a smile
grown out of tears.

Retirement in Shropshire: Pictures & Poems, Norman & Mary
Baldwin, published by Impress, London House, Town Walls,
Shrewsbury, 1979

Photo: Wenlock Edge, looking over Hope Dale towards
Brown Clee and Titterstone Clee Hills

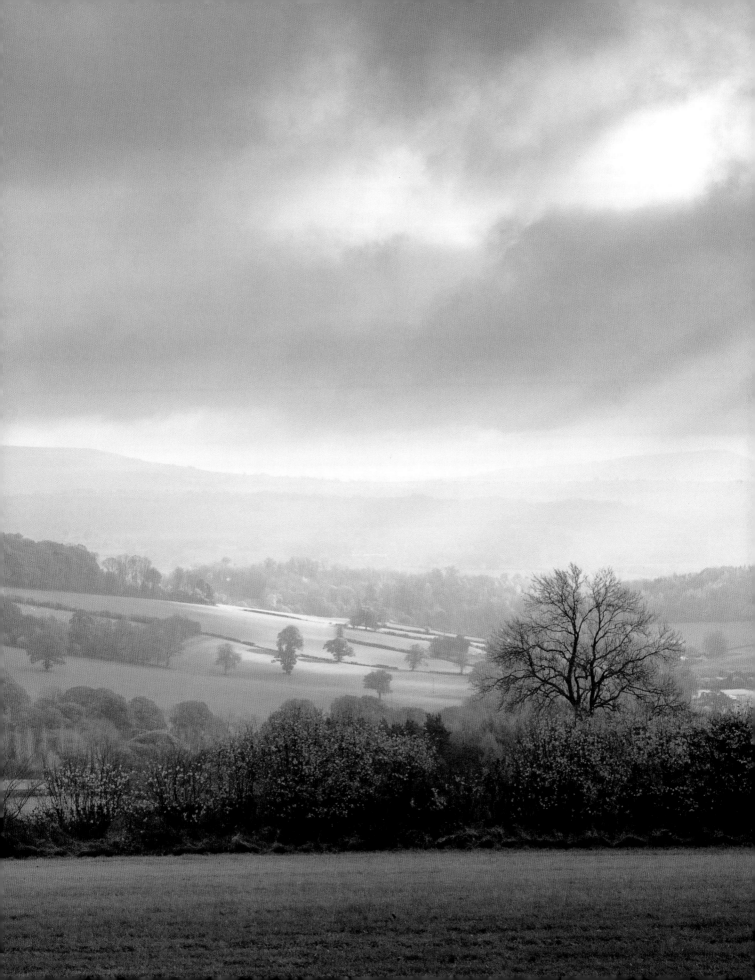

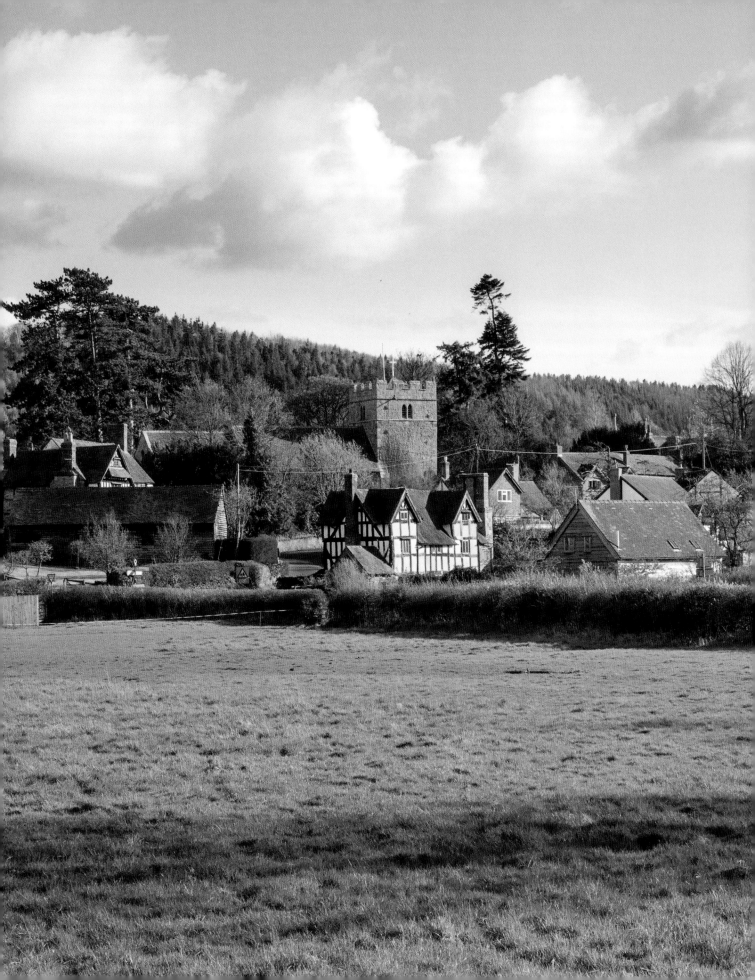

HAROLD JOSEPH PERKINS

A Shropshire Boy's Vision

From the age of six I went to Rushbury Elementary School, some two miles away, walking to and from with my two sisters and Tom. We had plenty of experiences at Rushbury School. A brook flowed some three fields away and, over the years, successive school kids had stanched the brook with branches and brushwood to create a dam. It raised the level to about a metre and a half, but did not stop the flow. On warm days during lunch hour we would race down there to swim.

One summer's day we were swimming in the brook and because the bank sides at that point were quite high above the water we did not see the landowner, Harry Hodgkiss, ride up on his horse. Without a word but grinning all over his face he leaned down from the saddle and scooped up our clothes that were abandoned on the bank with the handle of the crop. Three smart scoops and he had all our trousers, shirts and jerseys. No one wore underpants in those days. I am not sure whether they existed or were even necessary because shirts had very long tails with the rear flap pulled forward between the crotch reaching nearly to the navel, and the front tucked backwards, almost covering the bottom. So we were left with our boots and stockings to walk back over the three fields. We assumed our clothes would be dumped at the school and so made tracks back to there. The cattle did not worry us, although perhaps might have been amused at a dozen naked boys passing by, but the last 200 metres to the school was on the rough road around the vicarage wall.

We had just reached the road and were putting on our boots ready for the naked dash to school where we judged the clothes would be when some boys came out to us. It turned out the kids in the schoolyard had seen the clothes where Harry had left them at the school gate and reported their presence to Miss Farr, who immediately realized what had happened. Three of the big girls had offered to take them to us, but being the very compassionate woman she was, Miss Farr sent boys, realizing we would already be extremely embarrassed. To be goggled at by giggly girls would have been the last straw. Also, without doubt, they would have let on to their friends which boy might be the best catch!

Harold Joseph Perkins grew up on a farm in East Wall before war service took him to West Africa and Burma. He worked as an engineer in England, Spain and back in Burma before settling in Australia in the 1960s.

A Shropshire Boy's Vision, Harold Joseph Perkins, published by East Wall Press, 2010

Photo: Rushbury village and St Peter's Church, beneath Wenlock Edge

MALCOLM SAVILLE

Seven White Gates

Suddenly Peter (Petronella) remembered what old Henry had told her this very morning about a girl in Barton Beach who had seen the ghostly hunt.

"Jenny!" she gasped. "You didn't see the Riders, did you? You weren't the girl who saw them, were you?"

Jenny nodded. "I was… Oh! Peter. I've been scared to come here again and I thought if I came with you I'd be brave because you're so brave. But I'm not feeling very brave and it was about here it happened."

They had come now to the widest part of the valley. Ahead of them the Chair still loomed terrific over the head of the gorge and it was difficult to see how the track found its way up to the summit. Three hawthorns, their gnarled trunks white with sheep's wool, and two big boulders marked where their track divided with the left-hand fork leading over towards the old mines.

"We stopped here a bit," Jenny continued hurriedly, "to look in those trees and then, very quickly, it seemed to get dark and I said we'd better run for it 'cause if we didn't hurry it would be quite dark before we got home. And George said, 'Right-o,' and a cloud came up and we couldn't see much and suddenly… and suddenly, Peter, we heard horses galloping. 'Twas faint and far away, but we knew it was the Black Hunt. We ran home hard as we could and even as we ran we could hear those horses coming after us – sometimes quite close and sometimes far away. But it was them, Peter. I know it was, although I didn't actually see them and neither did George, but it was them and I'll tell you how I know. The Black Riders always come before something awful happens. Dad says they rode up here before the last war and this one too. And this time when we got home at last and George told someone, we began to wonder a bit, but next day old Humphrey up at your farm heard that his boy was a prisoner in Germany, so you see how right it is."

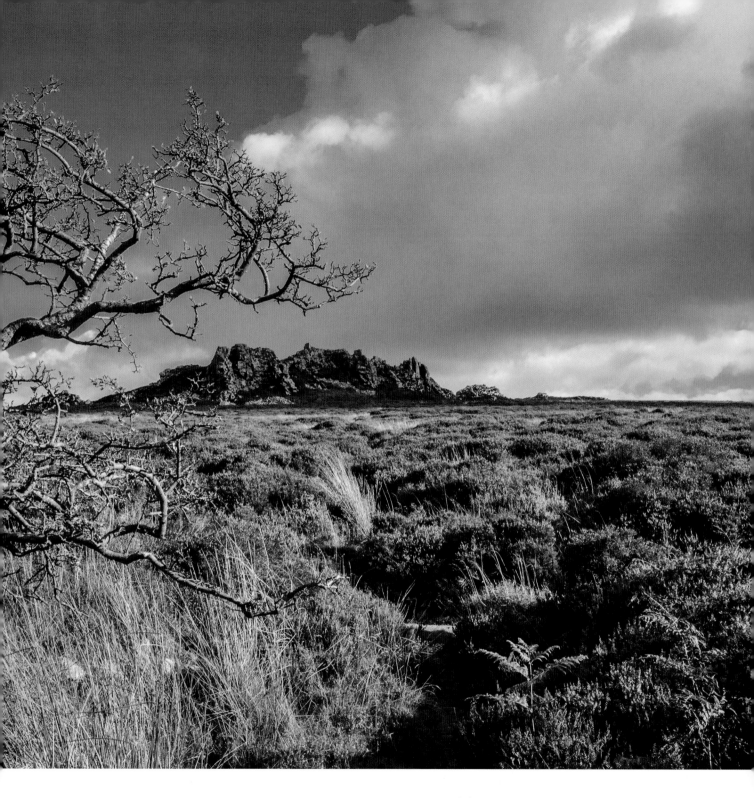

Malcolm Saville is best known for the Lone Pine series of children's books which were published between 1943 and 1978. Most are set in Shropshire.

Seven White Gates, Malcolm Saville, published by William Collins Sons & Co Ltd, London, 1970

Photo: The Devil's Chair at Stiperstones, under a passing storm

LUDLOW: *Various quotes*

It was like arriving in the circle at a theatre, and the whole of Ludlow was the set… the best, most focused, most enclosed view of a whole town she'd ever seen – this fairyland of castle and ancient streets, like a richly painted wheel around the spindle of the church tower, haloed by the molten glow of evening.

– Phil Rickman, *Smile of a Ghost*

Probably the loveliest town in England.

- John Betjeman
English Cities & Small Towns, 1943

By any standard, one of the best loved, best preserved and most aesthetically pleasing towns in Britain.

– Sir Nikolaus Pevsner

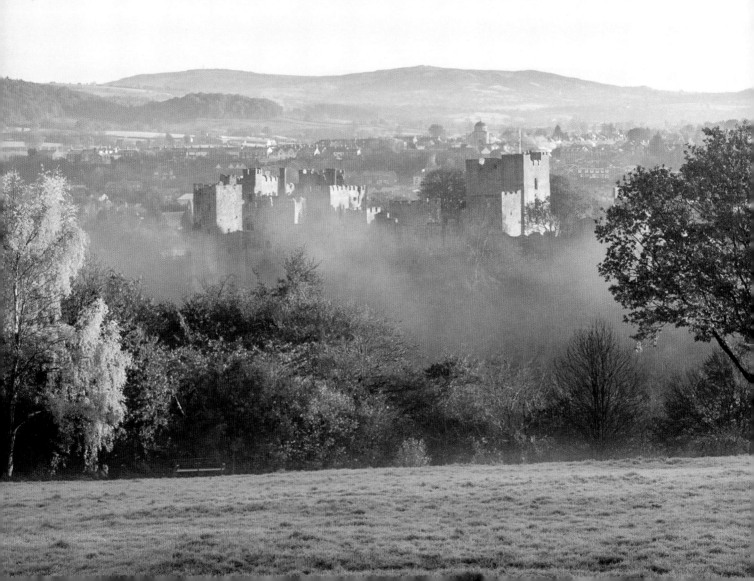

The towne doth stand most part upon an hill, Built well and fayre, with streates both large and wide… And who that lists to walke the towne about shall finde therein some rare and pleasant things.

– Thomas Churchyard
The Worthiness of Wales, 1587

The secret of Ludlow resides in the fact that, like York, it was once a seat of government in Tudor… England. A sense of its own identity and importance has never quite left it.

– Sir Roy Strong

Daniel Defoe *also visited Ludlow 1724-26:*

'The town of Ludlow is a tolerable place'

but obviously appreciated the castle more:

'the situation of the castle is most beautiful indeed'

'the castle itself is the very perfection of decay.'

Photo: Ludlow from Whitcliffe Common on a frosty November morning

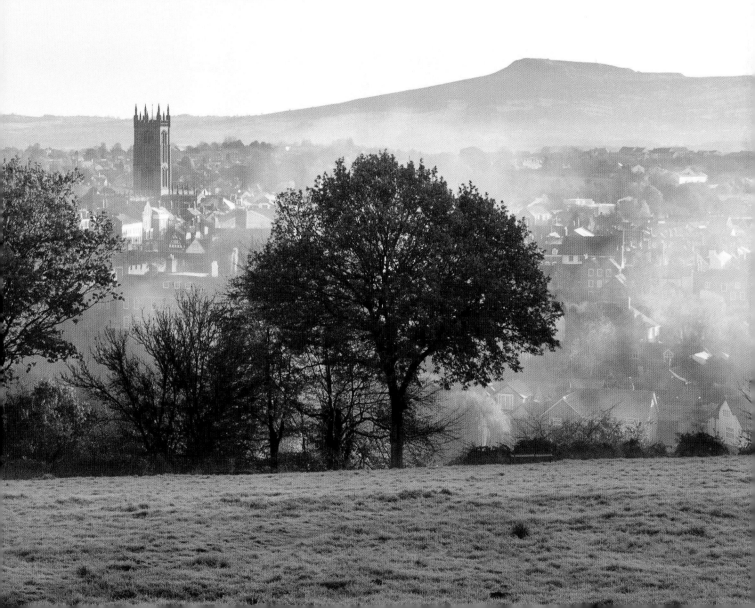

CHARLES DICKENS

The Old Curiosity Shop

They admired everything – the old grey porch, the mullioned windows, the venerable gravestones dotting the green churchyard, the ancient tower, the very weathercock; the brown thatched roofs of cottage, barn, and homestead, peeping from among the trees; the stream that rippled by the distant water-mill; the blue Welsh mountains far away.

It was a very aged, ghostly place, the church had been built many hundreds of years ago, and had once had a convent or monastery attached; for arches in ruins, remains of oriel windows, and fragments of blackened walls were yet standing; and fallen down, were mingled with the churchyard earth and overgrown with grass, as if they too claimed burying-place and sought to mix their ashes with the dust of men.

Some part of the edifice had been a baronial chapel, and here were effigies of warriors stretched upon their beds of stone with folded hands – cross-legged, those who had fought in the Holy Wars – girded with their swords and cased in armour as they had lived.

The child sat down, in this old, silent place, among the stark figures on the tombs – they made it more quiet there, than elsewhere, to her fancy – and gazing round with a feeling of awe, tempered with a calm delight, felt that now she was happy, and at rest.

Charles Dickens stayed in Tong – his grandmother was housekeeper at Tong Castle. Dickens said that the village in which Little Nell and her grandfather find refuge after fleeing London is based on Tong. There are several descriptions of the church as Little Nell becomes the keyholder. When the story became popular around 1910, a verger created a fake grave to Little Nell which he would show to visitors.

The Old Curiosity Shop, Charles Dickins, published by Chapman & Hall, London, 1841

Photo: Tomb of Anne Talbot and Henry Vernon with the Stanley monument behind, St Bartholomew's Church, Tong

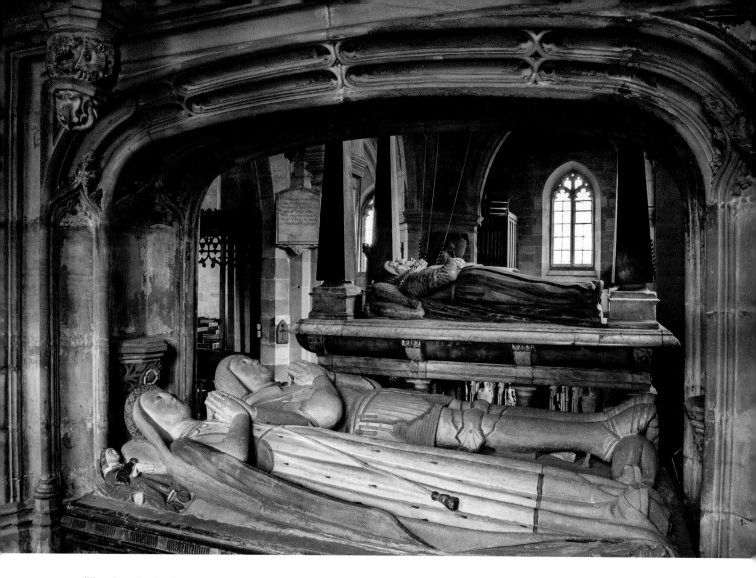

The church also has a connection with Shakespeare as one of the many magnificent tombs has lines of poetry which are said to have been written by him for this memorial.

Ask who lyes heare but do not weep,
He is not dead he dooth but sleep
This stoney register, is for his bones
His fame is more perpetual than theise stones
And his own goodness with himself being gon
Shall lyve when earthlie monument is none.

On the other end of the tomb:
Not monumental stone preserve our fame,
Nor sky aspiring pyramids our name
The memory of him for whom this stands
Shall outlive marbl, and defacers hands
When all to tymes consumption shall be geaven
Standly for whom this stands shall stand in Heaven.

HENRY JAMES

English Hours: A Portrait of a Country

A friend of mine, an American who knew this country, had told me not to fail, while I was in the neighbourhood, to go to Stokesay and two or three other places. 'Edward IV and Elizabeth', he said, 'are still hanging about there.' So admonished, I made a point of going at least to Stokesay, and I saw quite what my friend meant. Edward IV and Elizabeth indeed are still to be met almost anywhere in the county; as regards domestic architecture few parts of England are still more vividly old-English.

I have rarely had, for a couple of hours, the sensation of dropping back personally into the past so straight as while I lay on the grass beside the well in the little sunny court of this small castle and lazily appreciated the still definite details of mediaeval life.

The place is a capital example of a small gentil-hommière of the thirteenth century. It has a good deep moat, now filled with wild verdure, and a curious gatehouse of a much later period – the period when the defensive attitude had been well-nigh abandoned. This gatehouse, which is not in the least in the style of the habitation, but gabled and heavily timbered, with quaint cross-beams protruding from surfaces of coarse white plaster, is a very effective anomaly in regard to the little gray fortress on the other side of the court.

I call this a fortress, but it is a fortress which might easily have been taken, and it must have assumed its present shape at a time when people had ceased to peer through narrow slits at possible besiegers. There are slits in the outer walls for such peering, but they are noticeably broad and not particularly oblique, and might easily have been applied to the uses of a peaceful parley. This is part of the charm of the place; human life there must have lost an earlier grimness; it was lived in by people who were beginning to believe in good intentions.

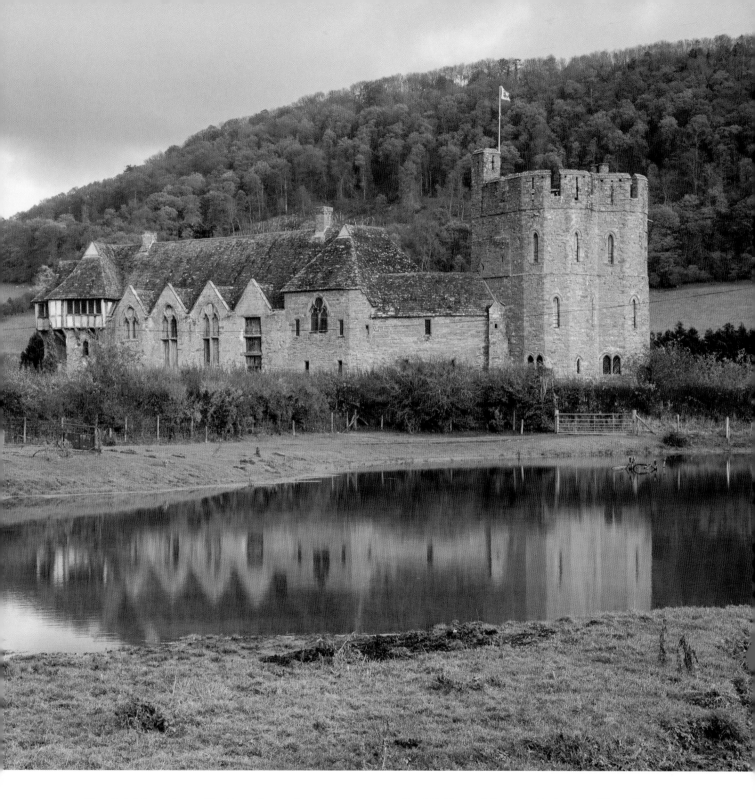

English Hours is a collection of travel essays on England written by Henry James (1843–1916) over a period of more than 30 years. Although American-born, James spent much of his life in England and became a British subject in 1915.

English Hours: A Portrait of a Country, Henry James, published by Heinemann, 1905

Photo: Stokesay Castle and St John the Baptist Church

JULIAN CRITCHLEY

A Bag of Boiled Sweets

As soon as the train left the platform my mother would begin her recitation: 'Condover, Dorrington, Leebotwood, All Stretton, Church Stretton and Little Stretton, Marshbrook and (pause for effect) Wistanstow Halt.' It was a litany of delights.

The halt was just that, two small, windy platforms, a hut and stern notices in cast-iron imploring us to look and listen before crossing the line. We did as we were told and, luggage to hand, walked the mile or more through the village, past Auntie Lizzie's house, the shop, the school and 'up the Common'. The welcome was warm, the cake made using dripping and with a sugared top, and then came the joy of running wild over the three surrounding fields: Church Field, the Pottocks and the Poorsland, which fifty years ago was undrained and marshy. Across the Pottocks was an oak wood, long felled and now replaced with dull pines. A stream ran through the garden feeding the well. At one side of the Patch it was overhung by an oak tree and there the shallow stream could be dammed by stones, old tomato-tins and much mud. There was a large yew tree by the gate. At the bottom of the garden were the pigsty, an old, dilapidated barn and a Shropshire two-seater, the sides of which were made of corrugated iron. The lavatory paper consisted of squares of last Sunday's News of the World, my introduction to the wonders of British journalism.

Julian Critchley was evacuated as a boy in 1939 to the cottage in which his mother was born, on Leamore Common, Wistanstow. After a parliamentary career (MP for over 25 years) he returned to Shropshire and lived in Broad Street, Ludlow with his first love, Prue Bellak, for the last years of his life.

Julian Critchley, *A Bag of Boiled Sweets*, published by Faber & Faber Ltd, 1994

Photo: Wildflower meadow by the River Perry, Ruyton-XI-Towns

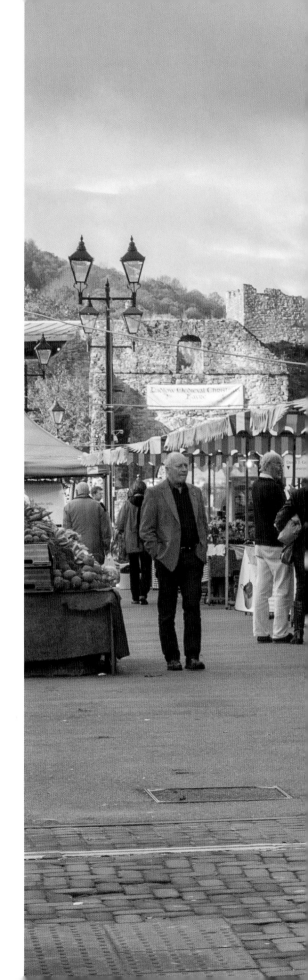

MARY WEBB

Golden Arrow

The markets at Silverton round about Lammastide are great days. Then you may see faces that you never see for the rest of the year--faces with quietness on them like a veil. To go into the market is to step back into multi-coloured antiquity with its system of the exchange of necessaries, and the beauty of its common transactions.

Fruit from deep orchards by lost lanes, from the remote hills; flowers from gardens far from any high-road; treasures of the wild in generous baskets – all these are piled in artless confusion in the dim and dusty place.

The Saturday after Deborah's departure to Lostwithin was the great wimberry market. The berries were brought in hampers that needed two men to lift them, and the purple juice dripped from them as in a wine-vat. Other fruit lay in huge masses of purple, gold and crimson. The air was full of its aroma. There were cheeses from dairies beside the great meres, that joined their waters across the fertile fields when the snows melted. There were white frilled mushrooms from pastures where the owl and the weasel lived undisturbed. These were gathered in the morning dusk, when dew made the fields like ponds, by barefooted young women with petticoats pinned above their knees--a practice that caused many a detour of young farm hands on the way to work. There were generous, roughly cut slabs of honeycomb from a strain of bees that were in these parts when Glendower came by. There were ducks with sage under their wings as a lady carries an umbrella. One stall was full of sprigged sun-bonnets, made after a pattern learnt in childhood by the old ladies that sold them.

Golden Arrow describes life in a poor farming community near The Stiperstones, the Devil's Chair forming a threatening glowering background. Set in the 1800s, the characters' stories may seem dated but Mary Webb's love of the Shropshire countryside is evident in the lyrical descriptive passages.

Golden Arrow, Mary Webb, Constable, London, 1916

Photo: Ludlow market, looking towards the Castle

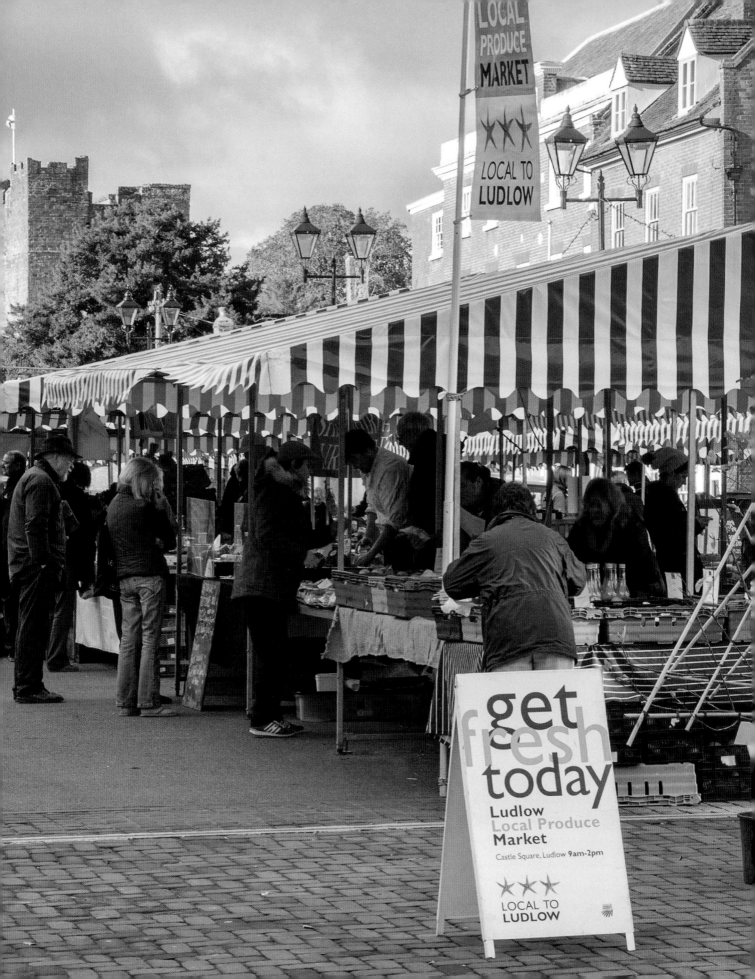

A. E. HOUSMAN

A Shropshire Lad

XXXI

On Wenlock Edge the wood's in trouble;
His forest fleece the Wrekin heaves;
The gale, it plies the saplings double,
And thick on Severn snow the leaves.

'Twould blow like this through holt and hanger
When Uricon the city stood:
'Tis the old wind in the old anger,
But then it threshed another wood.

Then, 'twas before my time, the Roman
At yonder heaving hill would stare:
The blood that warms an English yeoman,
The thoughts that hurt him, they were there.

There, like the wind through woods in riot,
Through him the gale of life blew high;
The tree of man was never quiet;
Then 'twas the Roman, now 'tis I.

The gale, it plies the saplings double,
It blows so hard, 'twill soon be gone:
To-day the Roman and his trouble
Are ashes under Uricon.

*AE Housman wrote 'I am Worcestershire by birth:
Shropshire was our western horizon, which made me
feel romantic about it.' Although a great classical scholar,
Housman is best known for his lyrical and pastoral
poems inspired by his lasting love of the countryside and
the 'blue remembered hills' of Shropshire. A Shropshire
Lad was published at his own expense in 1896 and has
been in print continuously ever since.*

A Shropshire Lad, A.E. Housman, 2009 edition published by
Merlin Unwin Books, Ludlow

Photo: Stormy weather over Eaton Coppice,
Wenlock Edge

L.T.C. ROLT

Landscape with Canals

It was late autumn and darkness had already fallen; yet I knew at once that I had hit upon a very special place, for as soon as I walked into the bar of the hotel my eye was caught and held by three large and handsome coloured engravings of local scenes which hung on the walls.

In the course of subsequent visits when, in the long summer evenings, I explored the Dale and the Ironbridge Gorge on foot, I came fully to share the feelings of those bygone artists. Although the famous iron bridge still spans the Severn, and men cast iron in the foundry at Coalbrookdale, the blast furnaces are dead [...] Bedlam furnace is no more than a cold ruin of crumbling blackened brick beneath a kindly veil of creeper. Yet the whole area seemed to me to be haunted. Everywhere I was reminded of the fierce activity of former days, and every stick and stone of the place seemed to have absorbed something of its white hot violence. It was here that Abraham Darby the First succeeded in smelting iron with coke instead of charcoal; here that the first iron hull was made and launched, the first iron steam engine cylinders and the first iron rails were cast; here the first steam locomotive was built to the design of Richard Trevithick. Yet I needed no such recital of historical facts to tell me that it was here that it had all begun. I could feel it on my pulses; and, if I needed any reminder, the great black semi-circle of Darby's iron bridge, springing over the Severn, spoke to me more eloquently than any history book.

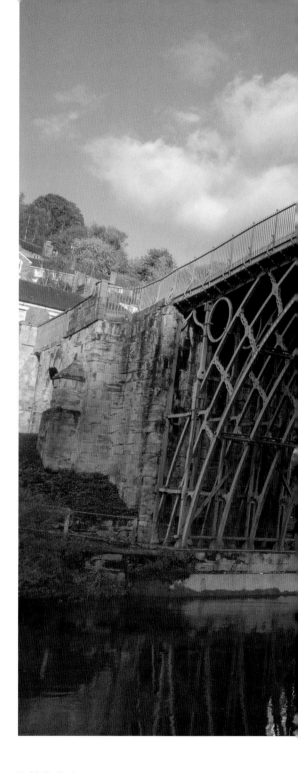

L.T.C. Rolt, *Landscape with Canals*, published by Allen Lane, 1977

Photo: The Iron Bridge from the banks of the river Severn

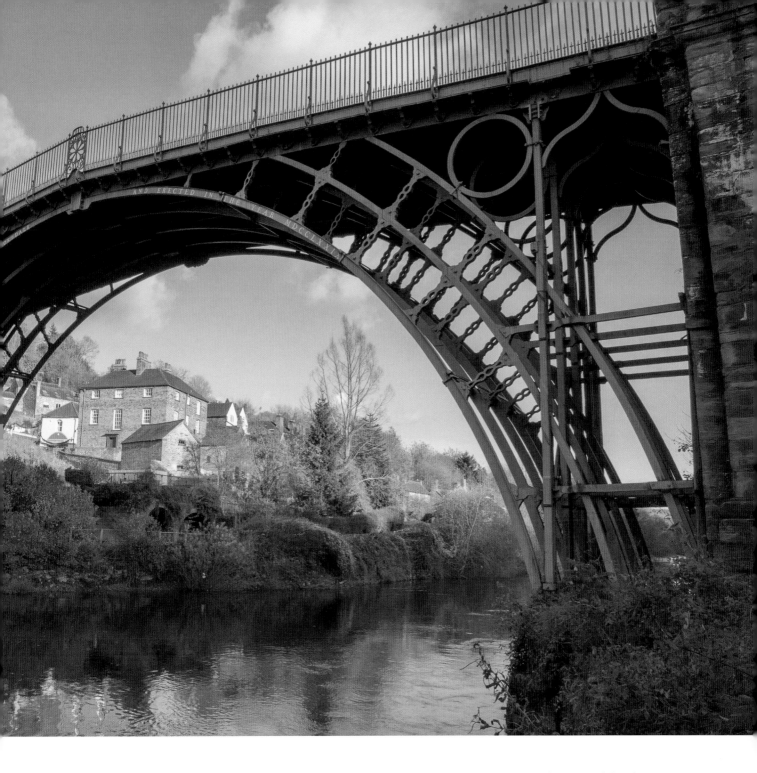

L.T.C. Rolt (1910-1974) was an engineer and writer who produced many works on civil engineering, canals and railways. Biographer of major civil engineering figures including Isambard Kingdom Brunel and Thomas Telford, he was a vital figure in the development of industrial archaeology and was joint founder of the Association for Industrial Archaeology. He was also instrumental in the survival of the country's canal system after it fell into disuse by drawing attention to its potential value for leisure activities and co-founding the Inland Waterways Association in 1946.

CHARLES DARWIN

The Bellstone

During my second year in Edinburgh I attended Jameson's lectures on Geology and Zoology, but they were incredibly dull. The sole effect they produced on me was the determination never as long as I lived to read a book on Geology or in any way to study the science.

Yet I feel sure that I was prepared for a philosophical treatment of the subject; for an old Mr Cotton in Shropshire who knew a good deal about rocks, had pointed out to me, two or three years previously a well-known large erratic boulder in the town of Shrewsbury, called the bell-stone; he told me that there was no rock of the same kind nearer than Cumberland or Scotland, and he solemnly assured me that the world would come to an end before anyone would be able to explain how this stone came where it now lay. This produced a deep impression on me and I meditated over this wonderful stone. So that I felt the keenest delight when I first read of the action of icebergs in transporting boulders, and I gloried in the progress of Geology.

One of the world's most influential and original scientists, Charles Darwin was born in Shrewsbury. His geology and zoology studies during a five-year voyage around the world on the survey ship HMS Beagle led him to formulate his theory of evolution and to develop his views on the process of natural selection.

The Life and Letters of Charles Darwin, published by John Murray, London 1887

Photo: The Devil's Chair on Stiperstones

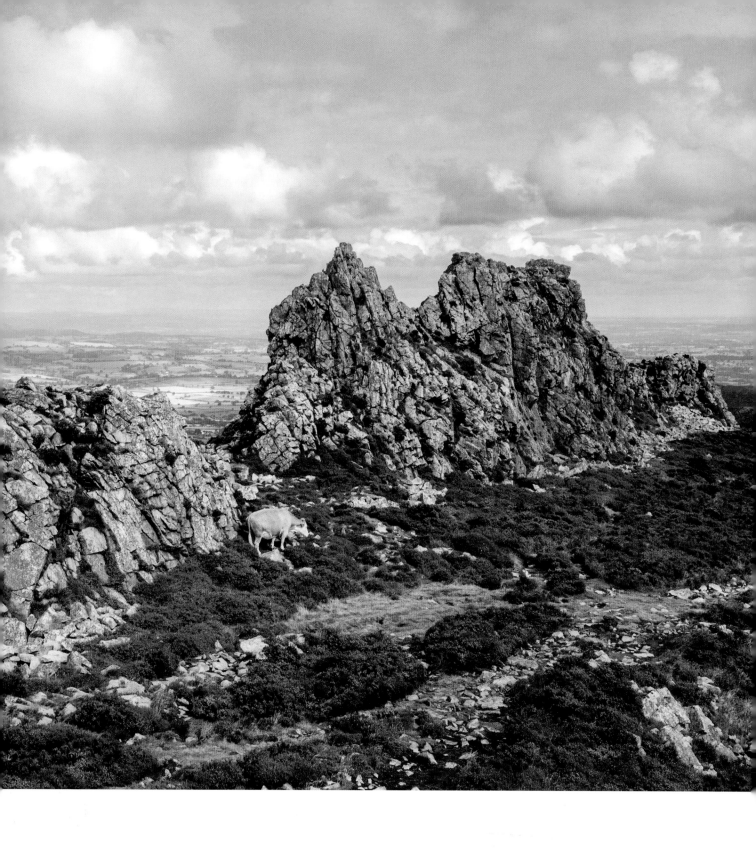

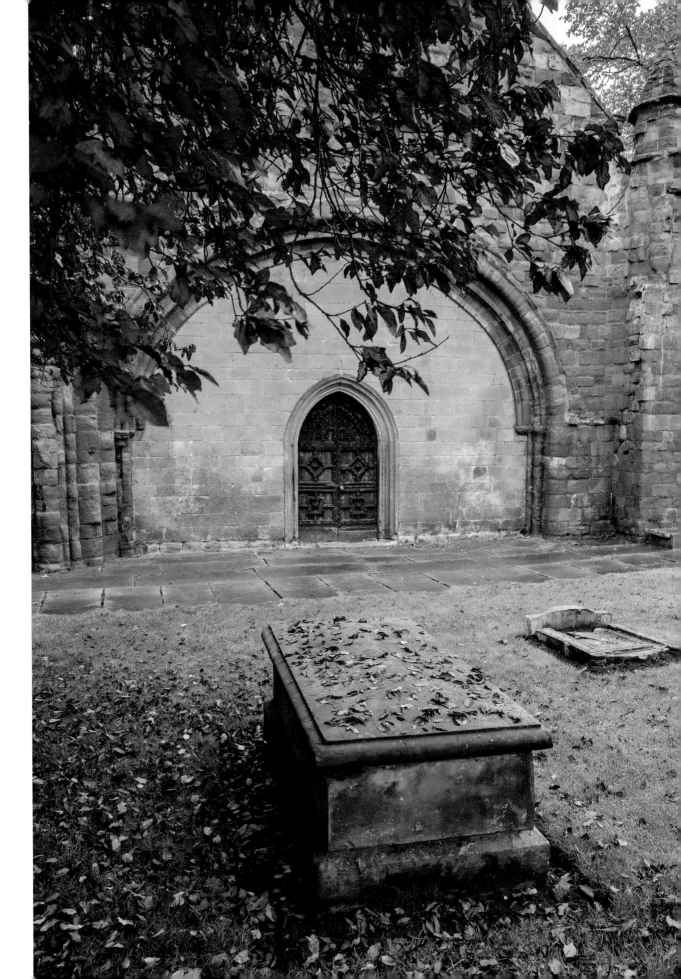

THOMAS PHILLIPS

The history and antiquities of Shrewsbury

In the summer of 1788 the churchwardens of St Chad's Church in Shrewsbury consulted Thomas Telford, the County Surveyor, on the cracks which had appeared in the tower of the church. It is said that he began his report, "I think, Gentlemen, that if you have any other business to discuss, you would be wise to continue your meeting elsewhere, since this church may fall down on our heads at any moment." However, his recommendations concerning the repair of the church were considered excessive and a stonemason was employed to carry out repairs instead.

On the second evening after the workmen had commenced their operations, the sexton, on entering the belfry to ring the knell previous to a funeral, perceived the floor covered with particles of mortar. On his attempting to raise the great bell, the tower shook, a shower of stones descended, and a cloud of dust arose. Trembling and in haste he descended into the church, and carried off the service books, and as much of the furniture as his alarm would allow him to collect.

On the following morning, July 9th, 1788, just as the chimes struck four, the decayed pier gave way, the tower was instantly rent asunder, and the north side of it, with most of the east and west sides, falling on the roofs of the nave and transept, all that part of the venerable fabrick was precipitated with a tremendous crash. Two chimney-sweepers, who were employed on their occupation in Belmont, witnessed the disaster. They described it as first exciting their notice by the sudden opening of the tower on the playing of the chimes. It stood for a moment, as it were suspended on the balance; as it sunk, a cloud of dust succeeded, which for a while concealed every surrounding object. The crash was heard by persons as far distant as the Old Heath, yet very few of the neighbouring inhabitants were alarmed by it; and their astonishment and dismay when they arose and beheld the desolation can scarcely be conceived. The morning, dark and rainy, added to the awful effect of the sad spectacle. The roof of the nave with the northern range of pillars and arches lay prostrate. That of the north wing of the transept was beaten in, and a great portion of the walls, together with three sides of the tower, lay in total ruin. The whole area was overspread with masses of stone, lead, and timber, in confused heaps, mingled with the shattered remains of pews, monuments, bells, and fragments of the gilded pipes and case of the noble organ. The whole of the south side of the tower hung in air, with portions of its beams, threatening destruction to any who should dare to approach them. From the altar, where only a spectator might stand with safety, the whole ruin was seen at once, forming a scene of desolation and horror, which will never be effaced from the memory of those who witnessed it.

The history and antiquities of Shrewsbury, Thomas Phillips, published by H. Washburne, London, 1837

Photo: Lady Chapel of Old St Chad's Church, Shrewsbury

THE WENLOCK OLYMPIAN SOCIETY

Wellington Journal
25 May 1872

These world-famed sports were held for the twenty-third time on Tuesday last, when, as a matter of course, they proved to be, in every sense of the word, an unparalleled success. Upon no former occasion has Wenlock entertained so many visitors, almost all of whom did not fail to appreciate and enjoy the lovely scenery of the neighbourhood, and other attractions.

Many scores availed themselves of the opportunity to explore the ruins of the fine old abbey, which stands in decayed and venerable grandeur a connecting link between this and a former period; nor, on this occasion, was the view of the abbey the only sight carrying the mind back to the 'Olden Time,' for one of the most attractive features of the Wenlock Games is the introduction of the exciting mediaeval contest of tilting at the ring – a contest which tests the mettle and training of horse and rider, requiring in the latter a strong and steady arm, a keen eye, and a resolute spirit…

The scene on the ground where the games were held was one of the most picturesque, varied, and animated. The decorations, flags, &c., the gay colours of the costumes worn by the mounted tilters and heralds, the gaily-dressed spectators grouped about the ground and the Windmill-hill, the Grand Stand, &c., formed an attractive and magnificent spectacle seldom witnessed.

Photo: St Milburga's Priory, Much Wenlock

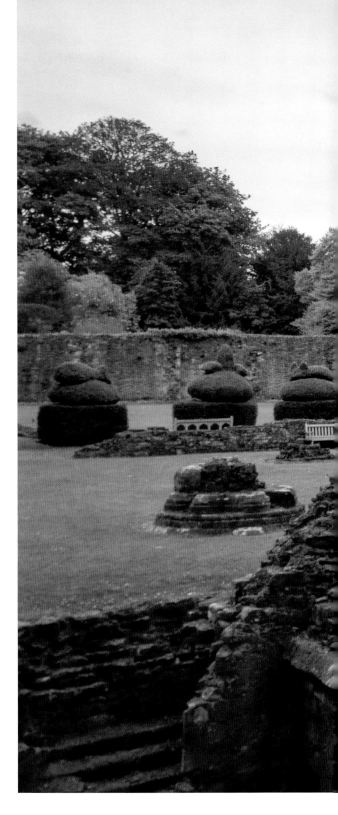

Dr William Penny Brookes was a doctor in Much Wenlock who, in 1850, created the Olympian Class (later the Wenlock Olympian Society) to 'promote the moral, physical and intellectual improvement of the inhabitants of the Town'.

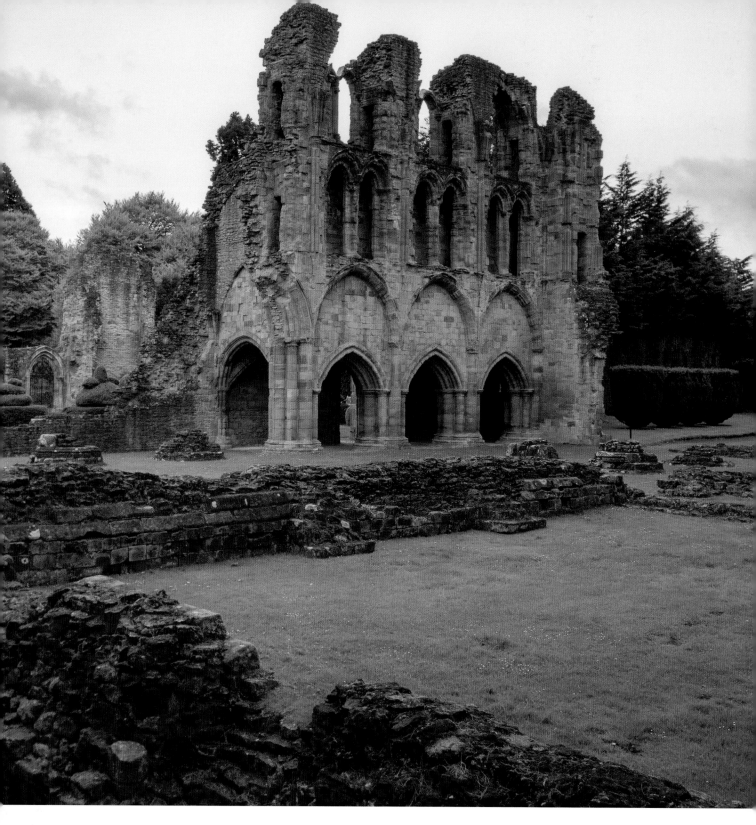

His campaign for the working classes to be involved in sport inspired Baron Pierre de Coubertin to establish the International Olympic Committee in 1894 and the modern Olympic Games.

In 1890 an English oak was planted in Much Wenlock to mark the Baron's visit. To celebrate the London 2012 Olympic and Paralympic Games, 40 oak trees, grown from acorns from the original oak, were planted between Much Wenlock and the Olympic Park in London.

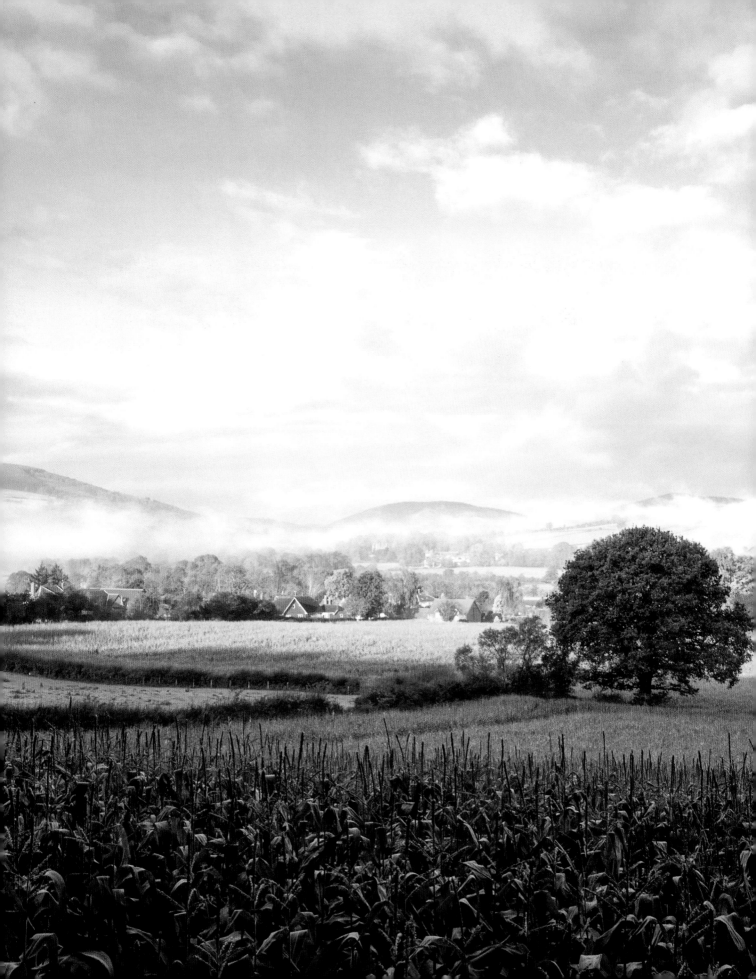

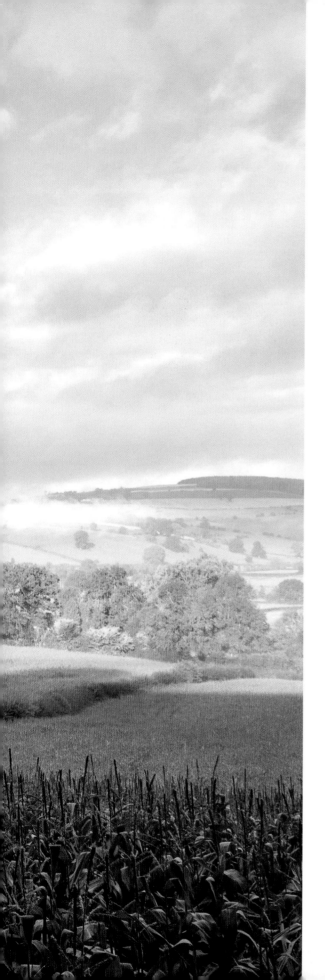

IDA GANDY

An Idler on the Shropshire Borders

One morning I got up when it was only half light. As I passed the little castle a number of calves peeped out at me from the doorway, followed behind for a short way, then scampered back.

Up on the hillside the dew formed a silver film; the valley below was a sea of mist. I settled down beside a fruitful clump of bushes and began to pick with early morning ardour. A lark let fall a few broken notes; small birds twittered in a subdued way; a flock of sheep lay placid and silent in the field below. We were all waiting for the sun. Suddenly there he was, a flaming ball on top of Stokesay Hill. Immediately the birds sang louder, the sheep got up and lifted their voices in a deep baa of salutation. All the mist in the valley turned to fire – rolling masses of red-gold fire. I stood entranced, raspberries forgotten. But when the glory faded I picked five pounds.

Ida Gandy was a doctor's wife who lived in Clunbury during the 1930s. She loved walking in the hills and also hearing and recording the stories of the villagers' lives.

An Idler on the Shropshire Borders, Ida Gandy, published by Wilding and Son Ltd, 33 Castle Street, Shrewsbury

Photo: Clunbury village and the Clun valley

TIM PEARS

Disputed Land

When Dad had come to collect me from my month-long visit that August and stayed for a long weekend, I'd gone to look for him one evening and found him in the field up above the house, sitting on the ground, leaning against the trunk of a beech tree. There was a glass of wine beside him, and he'd rolled himself one of his occasional cigarettes. I lay on the grass close by. It was only when he wiped his hand across his face that I realised my father had been weeping. After the moment it took me to recover from this unsettling sight, I asked him what he was sad about.

Dad shook his head. 'No, no, not sad, old chap,' he said smiling. 'Not at all. I'm happy, very happy.' He opened his arms, gesturing forwards. 'Look.'

Gazing over the top of the house, I watched the sun setting beyond the Long Mynd across the valley, where a patchwork of green and brown fields was wreathed in a hazy, buttery light. Smoke rose from slow-burning fires, and drifted on the breeze. The Welsh hills around the western horizon were blue. You could see isolated homesteads; odd hamlets which, as Grandpa had told me, 'were already old when the Domesday Book was drawn up'.

Dad reached over and drew me to him. 'I just love it here, Theo, that's all,' he said. 'This landscape. To perceive it, to be in it, to become part of it. That gives me great happiness.'

In Tim Pears' Disputed Land, Theo Cannon recalls the difficult family Christmas spent in Shropshire when he was thirteen and his grandmother's concerns about her legacy – both familial and environmental.

Disputed Land, Tim Pears, published by Windmill Books, 2012

Photo: View west over Abdon from Brown Clee Hill

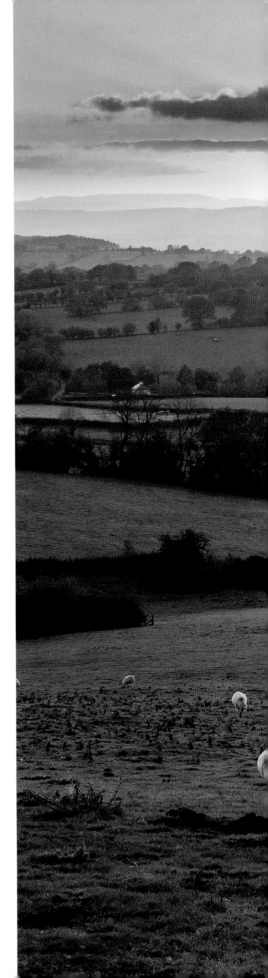

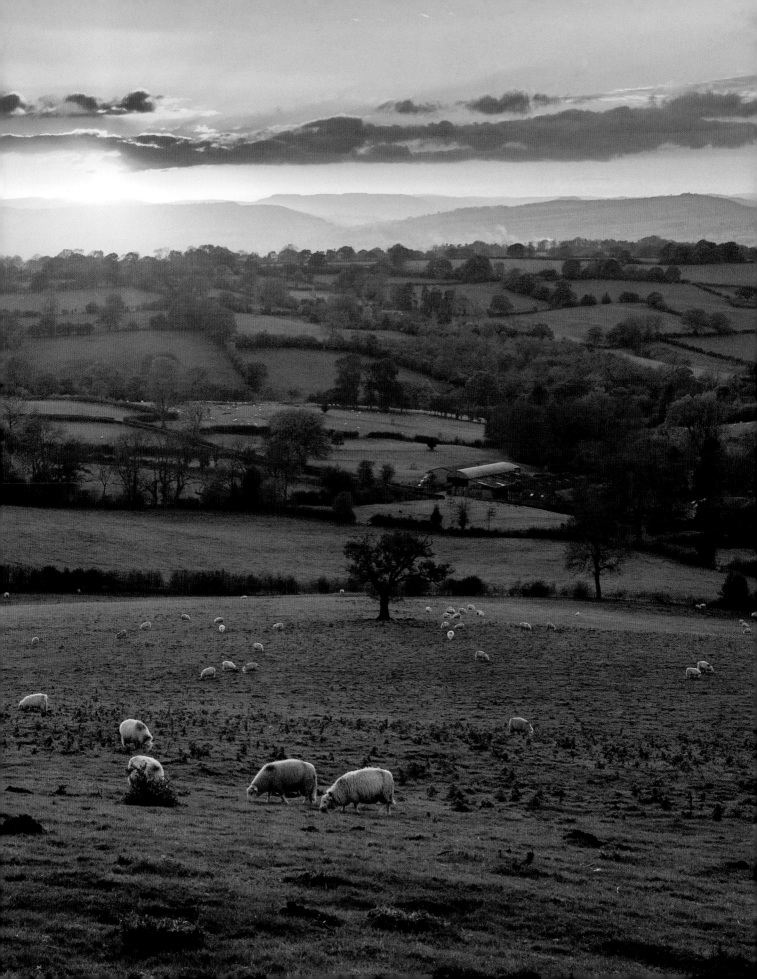

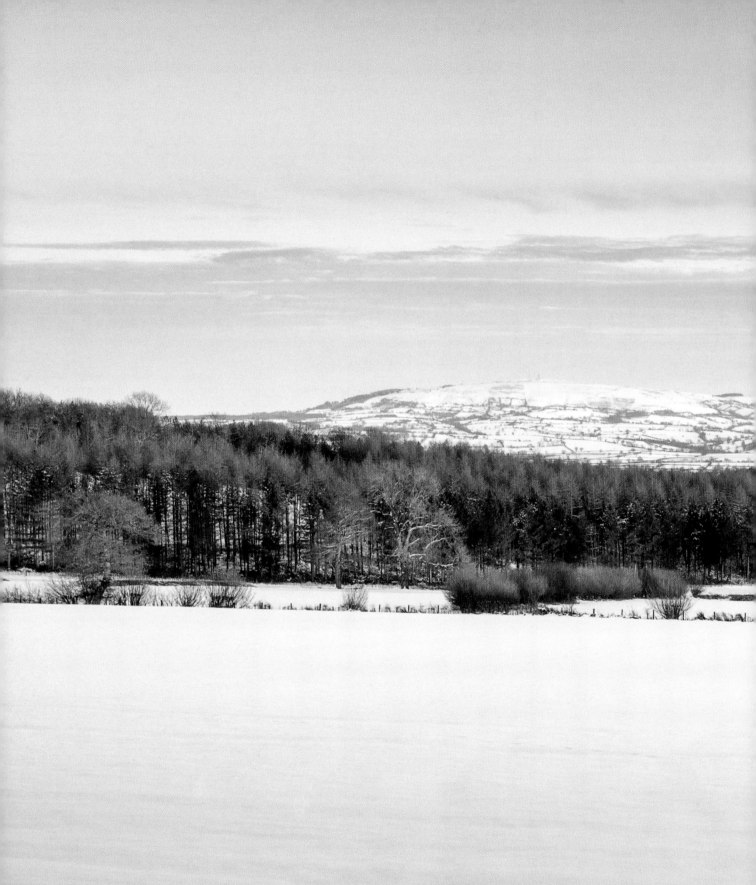

ELLIS PETERS

The Virgin in the Ice

All these four days since the first snow, the weather had followed a fixed pattern, with brief sunshine around noon, gathering cloud thereafter, fresh snow falling late in the evening and well into the night, and always iron frost. Around Shrewsbury the snowfalls had been light and powdery, the pattern of white flakes and black soil constantly changing as the wind blew.

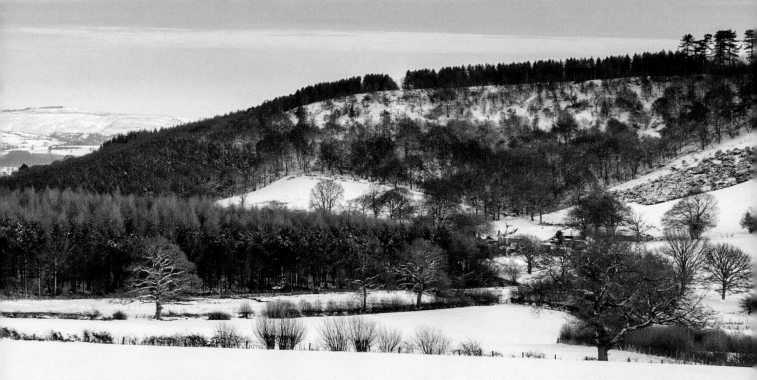

But as Cadfael rode south the fields grew whiter, the ditches filled. The branches of trees sagged heavily towards the ground under their load, and by mid-afternoon the leaden sky was sagging no less heavily earthwards, in swags of blue-black cloud. If this went on, the wolves would be moving down from the hills and prowling hungrily among the haunts of men.

Ellis Peters was the pseudonym of Edith Mary Pargeter (1913-1995). She was born in the village of Horsehay and lived all her life in Shropshire. She wrote 20 medieval mystery novels set in and around Shrewsbury Abbey about Brother Cadfael, the monk and herbalist.

The Virgin in the Ice, Ellis Peters, published by Macmillan London Ltd, 1982

Photo: Wenlock Edge, Sallow Coppice and Brown Clee Hill

JOHN BETJEMAN

A Shropshire Lad

The gas was on in the Institute,
The flare was up in the gym,
A man was running a mineral line,
A lass was singing a hymn,
When Captain Webb the Dawley man,
Captain Webb from Dawley,
Came swimming along in the old canal
That carried the bricks to Lawley,
Swimming along, swimming along,
Swimming along from Severn,
And paying a call at Dawley Bank while
 swimming along to Heaven.

The sun shone low on the railway line
And over the bricks and stacks,
And in at the upstairs windows
Of the Dawley houses' backs,
When we saw the ghost of Captain Webb,
Webb in a water sheeting,
Come dripping along in a bathing dress
To the Saturday evening meeting.
Dripping along, dripping along,
To the Congregational Hall;
Dripping and still he rose over the sill
 and faded away in a wall.

There wasn't a man in Oakengates
That hadn't got hold of the tale,
And over the valley in Ironbridge,
And round by Coalbrookdale,
How Captain Webb the Dawley man,
Captain Webb from Dawley,
Rose rigid and dead from the old canal
That carried the bricks to Lawley.
Rigid and dead, rigid and dead,
To the Saturday congregation,
And paying a call at Dawley Bank
 on his way to his destination.

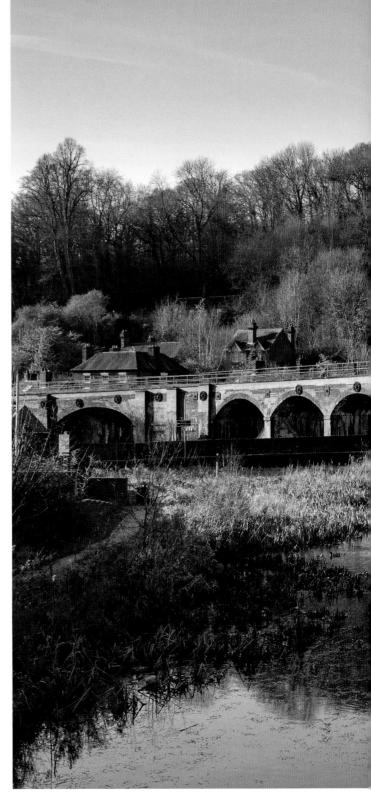

John Betjeman, writer, broadcaster and Poet Laureate, is connected with Shropshire not only through this poem but also as an architectural critic as he wrote The Shell Guide to Shropshire. In 1875 Captain Matthew Webb was the first man to swim the English Channel. Captain Webb was related by marriage to Mary Webb.

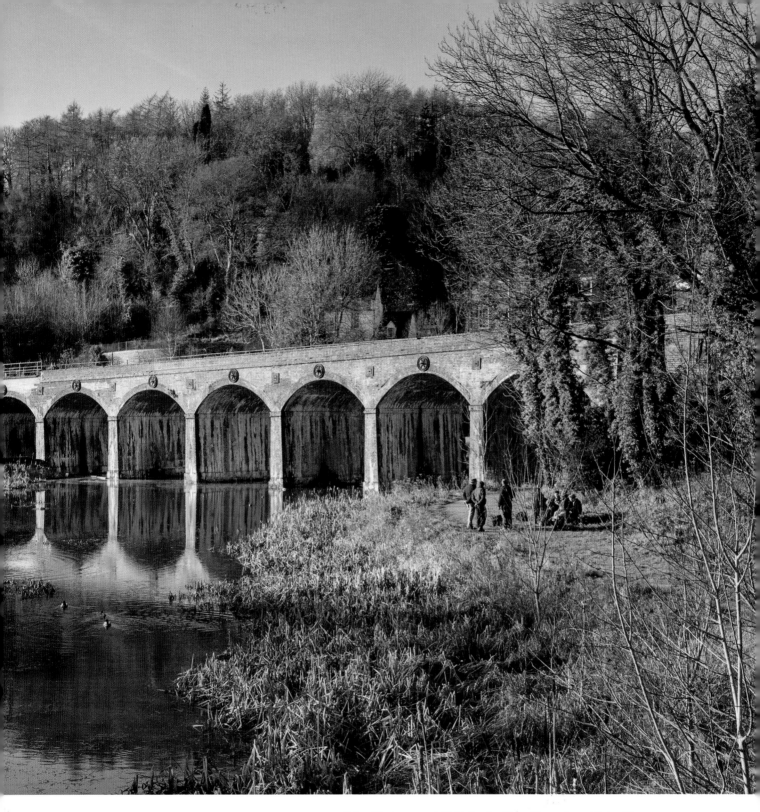

John Betjeman, *Old Lights for New Chancels*, published by
John Murray Ltd, 1940

Photo: Upper Furnace Pool and railway viaduct,
Coalbrookdale

FRANCES PITT

Country Years

I once surprised a barn owl bathing in a shallow part of the brook, and this in the early afternoon, no dull day either, but a lovely sunny one. I came quietly along the waterside, rounded a bend and there was the bird of the night, standing in the clear, rippling current, beating with its wings and splashing the water in flying glittering drops over itself and far and wide. The owl saw me almost at the same moment I saw it, and it immediately took flight, though with difficulty, for its plumage was so wet that it could hardly fly; however, it managed to depart, scattering a shower of glittering drops as it did so.

This woodland was quite a considerable area; not only were there the Westwood coverts, but on the opposite side of the valley stretched Thatcher's Wood, where in the spring the wild daffodils or Lent lilies were an annual joy. They went their wild way beneath the trees in most delicate beauty, shaking their pale yellow trumpets in the spring breeze like fairies in full skirts dancing on the red-brown bracken.

Frances Pitt was born in 1888 at Oldbury Grange, Bridgnorth and lived all her life in the area. She was a naturalist and pioneer in the field of wildlife photography and wrote many books on country life. As a small child, she became enthralled by birds, animals and nature in general and spent as much time as possible exploring the woods, fields and Mor Brook near her home at Westwood.

Country Years, Frances Pitt, published by George Allen & Unwin Ltd, London, 1961

Photo: Primroses in the woods near Erdington Mill

PETE POSTLETHWAITE

A Spectacle of Dust

Jax and I organised a few weekend visits to Shropshire and that was it, we fell in love with the county before we knew it. We packed up and moved to a shire that felt as though it had been designed especially for us. The gentle rise and fall of its hills, the tranquillity of its wide-open spaces and the curious idiosyncrasies of its market towns were like manna from heaven.

Our new house was a beautiful cottage in a small hamlet in south Shropshire. It had plenty of character and there were views over the local hills. We were surrounded by fields of sheep; the contrast between the hurly-burly of my working life and the bucolic bliss of Shropshire couldn't have been more pronounced. We were glad that our child would be raised there; we wanted him to be free to live an instinctive and true life.

Pete and his family lived first in Minton and then near Bishop's Castle. Pete loved coming home to his family in South Shropshire and said his shoulders 'dropped by two inches' whenever he came home.

A Spectacle of Dust: The Autobiography, Pete Postlethwaite, published by Weidenfeld & Nicolson, London, 2011

Photo: Small Batch near Little Stretton

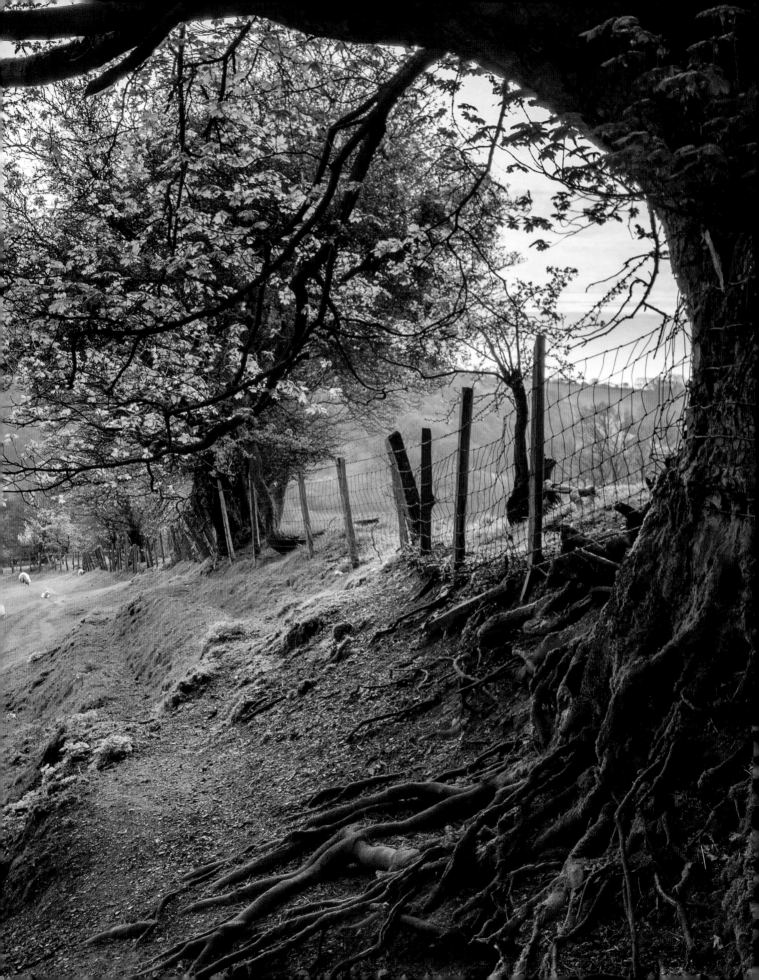

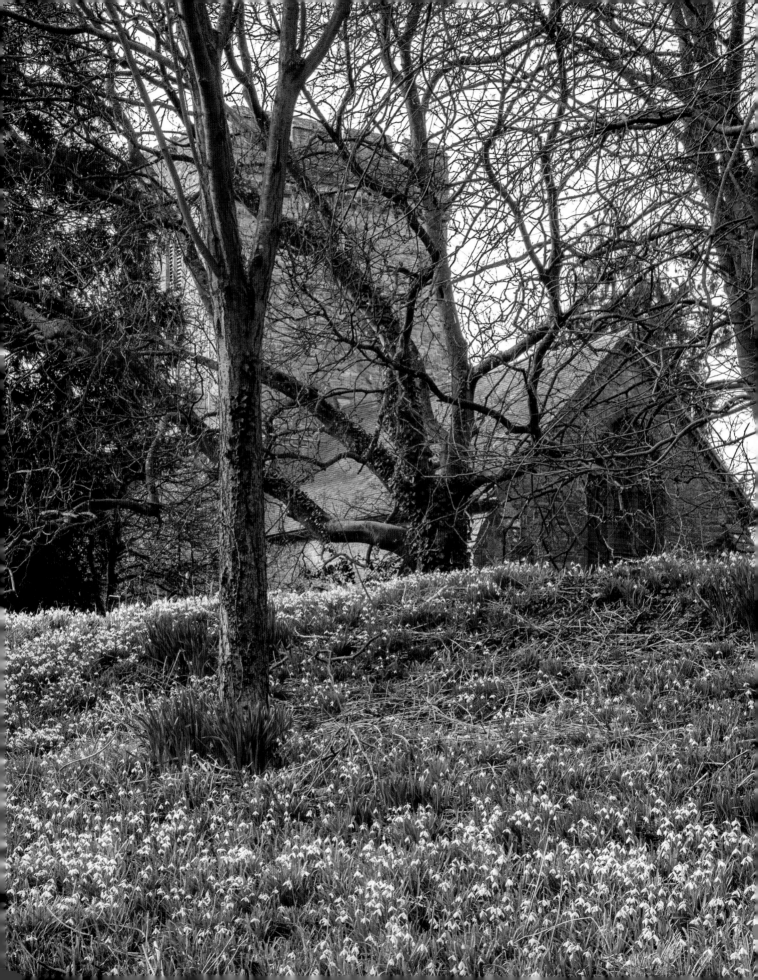

PETER KLEIN

The Temptation and Downfall of the Vicar of Stanton Lacy

On one particularly memorable occasion, Hopton and Chearme were told that Foulkes and Ann were keeping a tryst at the house of Francis Underwood in Stanton Lacy, to which they had gone 'by private and unusuall wayes', hoping to get together without raising suspicion. Underwood, it seems, was Ann's tenant and so had little say in the matter, in fact it was suggested that because of this he dared not interfere.

To confirm the truth of their information, Hopton and Chearme now called at the house on pretext of collecting Underwood's church dues; and on seeing his wife, Judith, they enquired whether Foulkes was there, only to be told that her husband was away, and that only she and her daughter were at home. They then asked her bluntly whether Foulkes and Ann were there together, which she denied, after which they now searched the house 'below stairs'. Here they found only a locked door to a 'little private room', and calling out to Foulkes asked him whether he remembered the bishop's admonition, 'and whether he were not ashamed to be there in company with a whorc, and bidd him for shame goe home to his wife', to which not surprisingly there came no reply.

They then withdrew but kept further watch, and after about half an hour they saw Foulkes come out and walk hurriedly away, Ann coming with him as far as the door, but stepping back when she saw that they were observed. Hopton called out to Foulkes, 'and asked him againe if he were not ashamed to keep company with a whore', to which Foulkes retorted 'Be hanged, you Rogue!' and hurried off through the fields, in a direction away from his own house and the village, 'diverse people following him, clapping their hands, and hooting at him'!

The charismatic Reverend Robert Foulkes was Vicar of the wealthy parish of Stanton Lacy, just outside Ludlow, until his execution at Tyburn in 1679. His name still appears on the original plaque in the ancient and atmospheric village church today. His remarkable fall from grace, and the village characters who played their part in it, has been pieced together by local historian Peter Klein.

The Temptation and Downfall of the Vicar of Stanton Lacy, Peter Klein, published by Merlin Unwin Books, 2005

Photo: Snowdrops at St Peter's Church, Stanton Lacy

ANNA MARIA FAY

Victorian Days in England

February 4th 1852

"We had a long-standing invitation from Lady Harriet to go to Oakley Park yesterday to lunch, and to walk about the grounds and visit the schools.

And thus, with so much to enjoy on our way, and so much pleasure in anticipation in meeting the Clives once more, we found ourselves again received in the vestibule by the portly butler, and the foot-men, this time in undress livery, blue coats and silver buttons, gray tights and unpowdered heads."

After lunch, they were shown around the house and were amused to discover that Miss Clive had a spinning-wheel which she used every evening from six to seven. The ladies then walked to the school.

"The school is over an old archway, once the entrance to an ancient priory, the remains of which adjoin the church. Hard by is the mill which makes the air vocal with its monotonous buzzing. A narrow flight of stairs admits us into the schoolroom in which the children rise as we enter. The room is long and the chimney stands in the centre, or perhaps I should have said two thirds the length of the room. The roof is timbered and the whole effect is quaint... The ages of the girls appear to range from four or five to twelve or thirteen. They were all dressed in stuff dresses and spotlessly white aprons. Their hair was smooth, and their hands perfectly clean. …. The boys were much younger than the girls, or rather they were all small, for the elder ones have to go into the fields.

"The ladies took the greatest pleasure in showing us the copy-books of the older girls and the slates of the little ones who were just learning. We examined the sewing of these, the marking of those, and the sums of the numberless little urchins. Then they sang for us admirably, one or more of the elder girls taking the second part. When the girls are fourteen or fifteen, they go out to service in Ludlow or the neighbourhood, and if they do well Lady

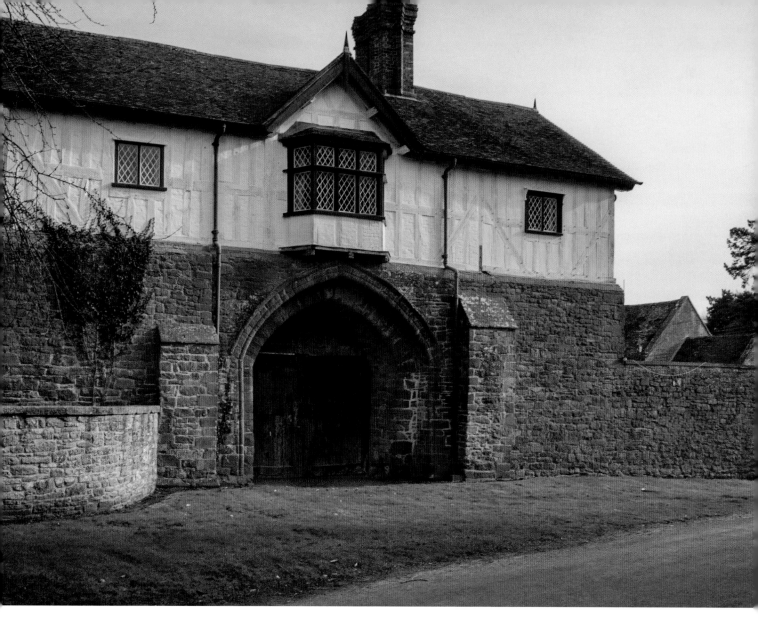

Harriet recommends them whenever she can. She is equally careful to provide amusements for them. In the yard was a swing and gymnastic exercises. At Christmas they have a Christmas tree upon which each child finds a present, and a tea party accompanies the festival. It is thus that these noble English women adorn their station. Miss Clive takes the greatest pleasure in visiting the cottages, and she knows every man, woman and child by name. In the Sunday school are seventy scholars, and the young ladies teach them there. It is delightful to see the good the Clives do, and then they are so charming in themselves, and so happy in each other. They treat one another with such politeness and such affection."

Anna Maria Fay stayed Shropshire in 1851–2 – an extended visit with her aunt, uncle and cousins. They lived at Moor Park near Ludlow and Anna Maria wrote to her family in Massachusetts describing her daily life, her surroundings and visits with the grand families of Shropshire.

Victorian Days in England, Anna Maria Fay, published by The Dog Rose Press, Ludlow, 2002

Photo: Gatehouse and the church of St Mary the Virgin at Bromfield

ANDREW BANNERMAN

Floreat Salopia

When Severn first sprang from the ground
And left her native Wales,
She sang for joy in winding round
Our hills and fertile dales

 So let our song go round and round
 And make the hills and dales resound
 Floreat Salopia!
 Floreat Salopia!
 Floreat Salopia!

On Wenlock's field was laid the course
Revived Olympus' flames.
Good Doctor Brookes became the source
Of mankind's greatest Games

Here Ashton's boys performed their plays,
Where Sidney tuned his lyre.
Young Clive to India turned his gaze,
While perched on Drayton's spire

The Romans tramped to Uricon,
Earl Roger raised his towers,
Rupert's troopers charged upon
But could not kill our flowers

Ours are the blue remembered hills.
The Iron Bridge spans our gorge,
Where mighty Darby iron spills
From his fierce, roaring forge

On Shrewsbury bugs was Darwin reared
Here are the Origin's roots.
And Haughmond's buttercups appeared
On Owen's warrior boots

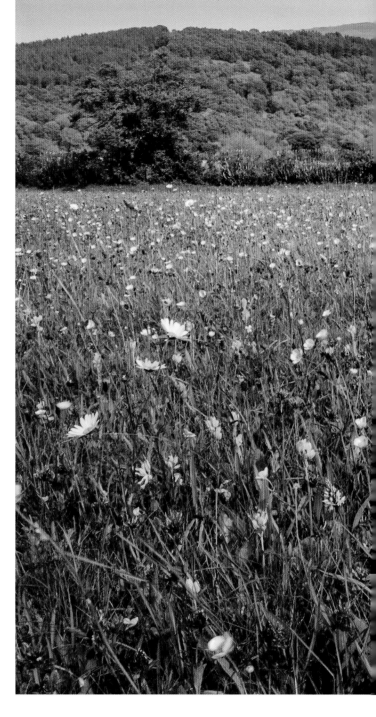

From Woore to Clun let bells be rung
And over Titterstone Clee.
By Ellesmere shall our song be sung
For Shropshire's jubilee

Let none despoil our fairest land
Let neighbours do no wrong.
Fair Ludlow join with Wem's strong hand,
To sing our county's song

Andrew Bannerman wrote this Festival Anthem when he was Artistic Director of the Shropshire Olympian Festival in 2011, to provide the event's finale. It was set to music by Mary Keith, a local composer and musical director and sung by combined choirs from all over Shropshire. A Theatrical Director and Drama teacher, he has lived in Shrewsbury since 1970 and currently works with Shrewsbury Youth Theatre.

Photo: Wildflower meadow at Marked Ash on Wenlock Edge looking towards Titterstone Clee

SYBIL POWIS

Goodbye to the Hills

Again I watch them slope away –
- The hills I love, as eastward I
Am carried. As the train slips by
The Wrekin's lion curve I know
That though once more forsaken, they
Live in my heart as now they lie,
Leaning to Wales in one long fortress sweep,
Indigo ramparts on the rain-filled sky.

Goodbye – and yet you hold me fast, you hills.
Breidden's far peak and Caradoc's rough crest,
Desolate Long Mynd, massive shouldered Clee,
Your beauty as you flow into the west,
Lovely and changeless hills, shall go with me.

*From Between the Severn and the Wye: Poems of the Border
Counties of England and Wales*, selected by Johnny Coppin,
published by the Windrush Press, Moreton-in-Marsh, 1993

Photo: Caer Caradoc, The Lawley
and The Wrekin from the Long Mynd

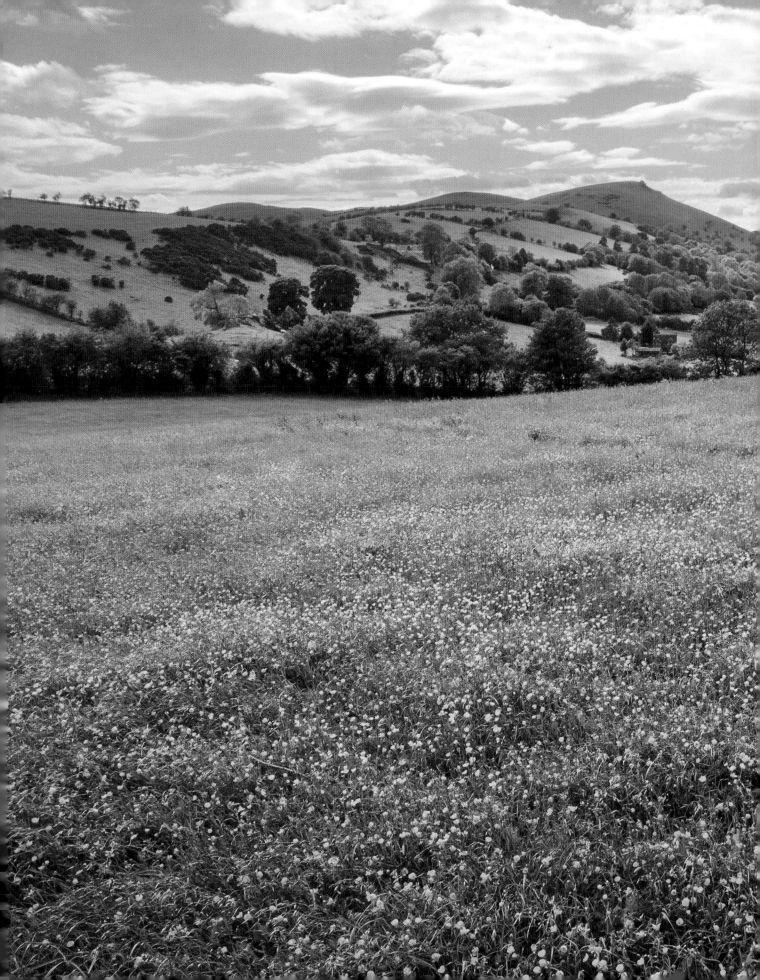

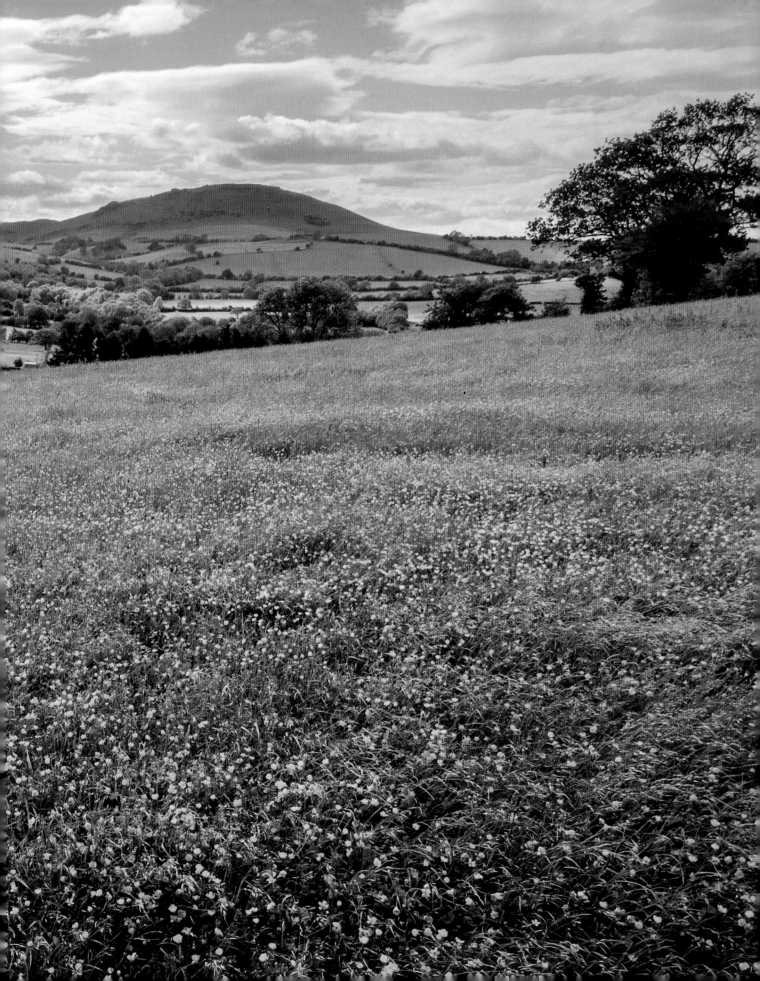

Photographer's notes

My photographic endeavour for this book has been to make each image resonate with the literature. Many of the pictures depict a familiar Shropshire landscape or building but the intention has always been to go further than this. For each piece of writing, the image was to enhance and complement the text, visually echoing at least some of the author's inspiration.

Pictures were captured digitally using a Nikon D300 camera and virtually all were taken with a single zoom lens 16–85 mm. Although my camera equipment is intentionally minimal, I always carry a tripod, which I consider essential to my practice. Raw capture was used with processing via Adobe Lightroom. I have not found it necessary to use Photoshop on any of these images; realism is one of the great strengths of the photographic medium.

It has been a privilege to work on this project with Merlin Unwin Books and Margaret Wilson.

p.i Orchid and wildflower meadow near the hamlet of Marked Ash on Wenlock Edge.

p.viii The idyllic country lane leading to Rushbury village, at the foot of Wenlock Edge.

p.1 Carding Mill Valley and Bodbury Hill, January 2013. In May, planning images for the book, we accepted that the following winter might not actually bring any snow; but in the event there was no shortage of the white stuff.

p.2 Foxgloves and bracken on Little Caradoc. My wife alerted me to the amazing display of foxgloves here. Three visits were needed to do justice to the scene.

p.5 Drive leading to Morville Hall and the church of St Gregory the Great. The avenue of trees along the drive was ablaze with colour on this early November morning.

p.6 Caer Caradoc from Gogbatch, one of many exquisite batches (valleys) on the flanks of The Long Mynd.

p8 A field of buttercups in Rushbury, below Wenlock Edge. After the hay is cut, this meadow is grazed in the autumn; the sheep then moved to another pasture, allowing wild flowers to blossom the following spring.

p.10 Church Street and St Leonard's Church, Bridgnorth. The low sun, just before dusk, has created some interesting reflections.

p.12 Turning the hay at Conery farm, near Lydbury North, looking west towards a patchwork of fields. The summer had been very wet; at the first spell of dry weather, the landscape became hyperactive, the scene changing by the day with tractors cutting and turning the hay, then baling into higgledy-piggledy rows.

p.15 Darnford Brook, Ratlinghope. With my tripod and wellies dipped in the stream, I had time to contemplate and carefully frame my picture.

p.16 Pim Hill organic farm, around five miles from Little Ness. Poppies and other wild flowers are less common with modern farming methods that use chemical pesticides and fertilizers.

p.18 Asterton Prolley Moor from the Long Mynd. This viewpoint is just beside the steep road up from Asterton village – a road not for the faint hearted!

p.20 Wenlock Edge, near Jacob's Ladder. After a hoar frost that had persisted for several days, the sun finally broke through on this very still morning. Jacob's Ladder is a ridiculously steep footpath that climbs from the village of Eaton on to the Edge.

p.23 The field of the battle at Haughmond Hill, near Uffington. Picture shows Douglas's Leap – where the Earl of Douglas, fleeing from the Battle of Shrewsbury, was thrown from his horse and captured by Henry IV's men.

p.24 Packetstone Hill at dusk. The sun had long since set when this scene revealed itself, above the village of Minton. The lone sheep added to my sense of awe.

p.26 Ludlow Castle, the north rampart of the Inner Bailey, viewed from the Castle Walk. As the writing in this novel is somewhat other-worldly, I felt that the image should take a similar approach.

p.29 Hope Valley forest. In the late afternoon light this nature reserve becomes a magical place. Dormer Valley is actually Hope Valley near Snailbeach.

p.30 Diamond Jubilee beacon on Caer Caradoc Hill, 4th June 2012. I watched the celebrations unfold from the flanks of Gaer Stone hill.

p.32 Edge Farm and Eastwall Coppice, near Longville. Late spring and the wheat is ripening.

p.34 Willows by the English Bridge on the Severn at Shrewsbury. The spire of the United Reform Church can be seen behind the trees. Whilst exploring the riverbank here, an otter appeared in the river not far away.

p.37 A bend in the River Rea at Hinton, near Stottesdon. I was offered the loan of some waders for this picture but managed (just) with wellington boots.

p.39 Looking east along Market Street, Ludlow. The produce hanging outside this butchers shop varies through the seasons with hare, pheasant and other game birds; then in the summer there are baskets of flowers.

p.40 St Mary's with the crooked spire, Cleobury Mortimer. Having explored a variety of viewpoints around the church, waiting for suitable light and parked vans to move, this opportunistic shot works quite well.

p.42 Bury Ditches looking east, 6 October 2012. Was this good planning or serendipity on dates? *The Guardian* published this diary on 4 October 2011. On this visit, Bury Hill resonated perfectly with Paul Evan's writing.

p.44 Gatehouse to Whittington Castle, near Oswestry. This is one of a chain of castles along the Welsh Borders.

p.46 Duddlewick, near Moor Brook Meadows. You don't need to be a birder to become entranced by the curlew's call. I hope that this image has captured something of the feeling in Simon Evans's writing.

p.48 The ruins of Viriconium's public baths at Wroxeter, near Shrewsbury.

p.51 Wenlock Edge, above Middlehope. Wenlock Edge is a reclusive landscape with few walkers; my photographic explorations are normally undisturbed by human presence.

p.52 Asterton Prolley Moor from The Long Mynd. This is close to the Gliding Club - a great place to see gliders and hang gliders in action.

p.54 The Mere at Ellesmere. A variety of waterfowl came looking for attention but this lone swan fits the frame.

p.57 Ravine leading to Grotto Hill, Hawkstone Park. Hawkstone Park Follies was a genuine magical mystery tour.

p.58 Family butchers D.W. Wall & Sons, High Street, Ludlow. An image captured in September 2012.

p.61 The Wrekin from Harnage, looking across the River Severn. Although much lower than other hills in Shropshire, The Wrekin is an iconic landmark that appears on the horizon from almost everywhere.

p.62 Ewes at Manor Farm, Easthope. Mary Webb lived at The Grange, Much Wenlock, between 1882 and 1896, near these fields. She was probably familiar with this view.

p.65 Dean Park, Burford, near Tenbury Wells. This is the most southerly tip of Shropshire.

p.66 Wenlock Edge, looking over Hope Dale towards Brown Clee and Titterstone Clee hill. For landscape photography, I carefully plan my visits to locations but serendipity still plays a huge role.

p.68 Rushbury village and St Peter's Church, beneath Wenlock Edge. The school is just out of sight behind the church tower; it is still very active and the sound of children playing can be heard across the fields.

p.70 The Devil's Chair at Stiperstones, clearing storm. Shortly before capturing this picture, from above Perkins Beach, I had to retreat into my weatherproof gear while the storm raged.

p.72 Ludlow from Whitcliffe Common on a frosty November morning, mist is rising from the River Teme.

p.75 Tomb of Anne Talbot and Henry Vernon with the Stanley monument behind, St Bartholomew's Church, Tong. The artefacts contained in this church are quite amazing.

p.76 Stokesay Castle and St John the Baptist Church. You can understand exactly what Henry James is saying here.

p.79 Wildflower meadow by the River Perry, Ruyton-XI-Towns. I had been exploring north Shropshire with an agenda of images for the book; the weather had been dull and unpromising. Finding this beautiful wildflower meadow was like discovering a carpet of jewels.

p.80 The Local Produce Market in Ludlow, looking towards the Castle with Whitcliffe hill beyond. I can thoroughly recommend the market produce.

p.83 Brooding weather over Eaton Coppice, Wenlock Edge. The light and sky were constantly changing, so careful timing was needed here.

p.84 The Iron Bridge from the banks of the Severn. I always said that I would never photograph the Iron Bridge; so many artists and photographers have made their own interpretation. I hope that my image conveys something of the strength and beauty of Abraham Darby's creation.

p.86 The Devil's Chair on Stiperstones with a lone cow! I was amazed to arrive at this remote location and find a small herd of cows grazing amongst the heather.

p.88 Lady Chapel of Old St Chad's Church, Shrewsbury. The fallen autumn leaves seem an apt accompaniment to this collapsed church building.

p.90 The ruins of Wenlock Priory, in the little market town of Much Wenlock.

p.93 Clunbury village and the Clun valley. As the sun rose above the hill, I found myself unsure where I should be to capture the right image; I think that my persistence paid off.

p.94 View west over Abdon from Brown Clee Hill. When I first visited this location it happened to be a Sunday. As dusk approached a sound began rising from St Margaret's Church below, a chiming of two bells, autochthonous, almost primaeval. Abdon is the site of a mediaeval village.

p.96 Wenlock Edge at dusk, Sallow Coppice and Brown Clee Hill. The severe winter weather confers a strange beauty, the reddish-brown colour of the Sallow Coppice larches complement the cold, blue-tinted snow. Brown Clee is the highest point in Shropshire at 540 m (by a small margin).

p.98 Upper Furnace Pool and railway viaduct, Coalbrookdale. This whole area is steeped in industrial heritage. The group of people in the picture appeared to be on an educational visit.

p.100 Primroses in an ancient wood near Eardington Mill. The Mor brook runs close by.

p.102 Footpath from Little Stretton running along the edge of Small Batch valley in late spring.

p.104 Snowdrops at St Peter's, Stanton Lacy. The churchyard is renowned for its annual display of snowdrops, although my photographic efforts were nearly thwarted by scaffolding surrounding the church for structural refurbishment.

p.106 Bromfield Gatehouse and the church of St Mary the Virgin. The Gatehouse is currently used for holiday accommodation through The Landmark Trust.

p.108 Wild flower meadow at Marked Ash on Wenlock Edge, looking towards Titterstone Clee. This location, close to Roman Bank, has some of the best wildflower meadows in the county.

p.111 Caer Caradoc Hill, The Lawley and The Wrekin from the Long Mynd. Early morning from Grindle Hill, looking over Ashes Hollow towards (from right) Caer Caradoc and Lawley with The Wrekin in the far distance. An exhilarating December morning, though bitterly cold and windy.

p.112 Willstone Hill from Hill End, near Cardington. This buttercup meadow is one of several options that were considered for the Wilfred Owen Spring Offensive poem. Each image has its own visual qualities and varied interpretation.

Geoff Taylor, Rushbury, July 2013

INDEX

Acknowledgements

Very special thanks to Geoff Taylor, photographer, and all the staff at Merlin Unwin Books but particularly to Karen McCall and Merlin Unwin for their enthusiasm and encouragement throughout this project. For assistance and advice, I would also like to thank the staff at Shrewsbury and Church Stretton libraries; Dr Matt Thompson, Senior Curator at The Ironbridge Gorge Museum Trust; Chris Cannon, archivist at Wenlock Olympian Society; Andrew and Annie Bannerman; Ros Ephraim and Hilary Jones at Burway Books; Sue Ellis, Castle Manager at Whittington Castle; Lorna Taylor, Margaret Tremellen and, of course, John and David Wilson.

Margaret Wilson

Also published by Merlin Unwin Books

A Shropshire Lad A.E. Housman. Photographs by Gareth Thomas
It Happened in Shropshire Bob Burrows
The Concise History of Ludlow David Lloyd
The Temptation and Downfall of the Vicar of Stanton Lacy Peter Klein